OBSCURE

ANDY VELLA

observing the cure

PUBLISHED BY FORULI CODEX

FIRST EDITION

ISBN 978-1-905792-44-3

EDITED BY KARL FRENCH

A CIP CATALOGUE RECORD FOR THIS BOOK IS AVAILABLE FROM THE BRITISH LIBRARY

DESIGN BY ANDY VELLA, WWW.VELLADESIGN.COM

RuBBER TYPED

PRINTED BY LIGHTNING SOURCE

FORULI CODEX IS AN IMPRINT OF FORULI LTD, LONDON

WWW.FORULICODEX.COM

FOR ALL THE IMAGINARY

BOYS AND GIRLS

THIS IS A BOOK
OF DISAPPEARED
WORLDS
CAPTURED BY THE
VELLA LENS
FLEETING MOMENTS
ALTERED FACES
UNEXPECTED SPACES
BY TURNS
DREADFULLY FUNNY
TERRIBLY HONEST
STRANGELY MELANCHOLIC...

UNASSUMING/INTENSE
PURPOSEFUL/OBLIQUE
WILLING/INCURABLE...

I HAVE HAD
THE PLEASURE
OF KNOWING ANDY FOR
33 YEARS
AS A PHOTOGRAPHER
DESIGNER
ARTIST
AND AS A FRIEND...

I HOPE YOU ENJOY THIS
HIS OBSCURE
PICTORIAL TRIP
THROUGH TIME

...AS MUCH
AS I DID !

ROB LYX
2014

LIGHT AND DARK

1977. I was 16. I was given a camera by a tutor called Dick, a Yashica Mat twin-lens reflex. He taught me how to load the film and showed me around a light meter-and I was photographing, not really knowing what I was doing. I went down to Southsea beach and photographed a load of old wood and something happened, I was hooked. I developed the film and printed the images and I was totally smitten with the whole process, because it's beautiful. It's magical, it's alchemy. It's a metamorphosis, the capture of a fleeting moment, an idea becoming an image.

1981. POST PUNK WAS EXPLODING. I SAW THE CURE ABOUT FOUR TIMES BEFORE I WORKED WITH THEM, JUST AT THE LEVEL OF SEEING A BAND I REALLY LIKED.

We have a creative affinity I think.

SO I'M HIDING BEHIND MY CAMERA?

I GUESS I'M INCONSPICUOUS.

I HAVE NO FIXED IDEA OF THE IMAGE I'M AFTER. I ALWAYS LIKE AND TRUST SPONTANEITY.

I LOVE LIGHT AND DARK AND WHAT SITS IN THE MIDDLE.

I CERTAINLY WASN'T FEELING INTELLECTUAL WHEN I TOOK THESE, I JUST HAPPENED TO POINT THE CAMERA IN THE RIGHT DIRECTION.

IF SOMEONE SAID I COULD NEVER TAKE ANOTHER PHOTO I'D DRAW IT, PAINT IT, SCULPT IT INSTEAD.

WITH THE CURE I LOVE PUTTING IMAGES TO POETRY.

ANDY VELLA IS A PROFESSIONAL PHOTOGRAPHER AND DESIGNER, HE HAS BEEN TAKING PHOTOGRAPHS SINCE 1977.

HE HAS DESIGNED MANY CURE ALBUMS UNDER HIS OWN NAME AND ALSO WITH LONG TIME FRIEND PORL AS PARCHED ART .

ANDY WAS BORN AND BROUGHT UP IN SOUTHAMPTON, THE BIRTHPLACE OF BENNY HILL AND KING CANUTE.

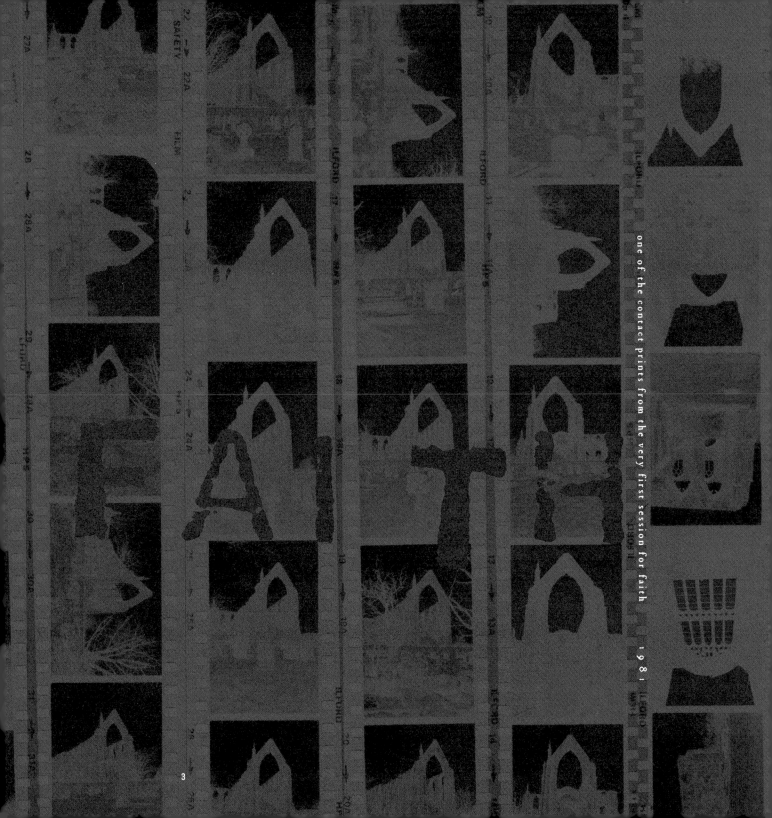

one of the contact prints from the very first session for faith

1 9 8 1

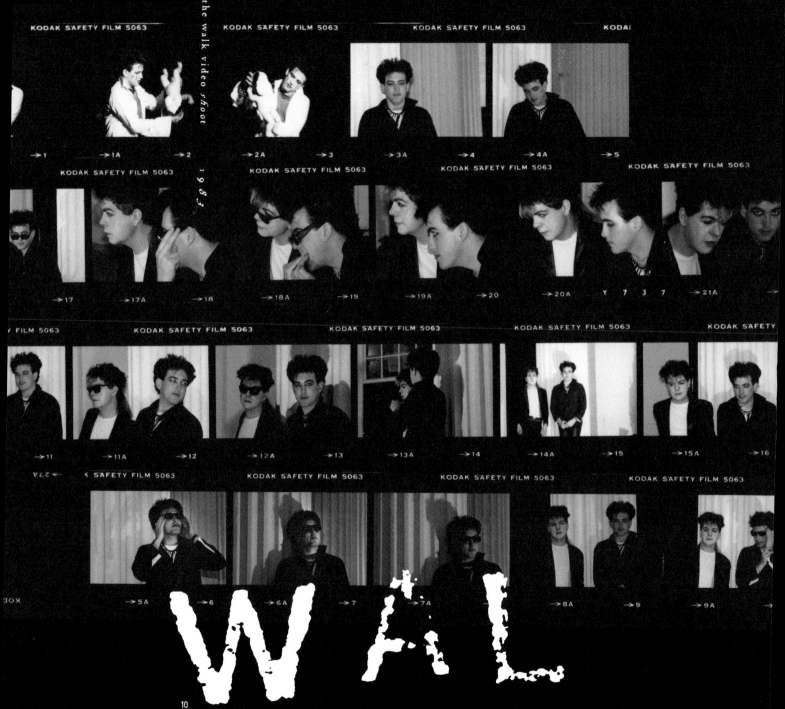

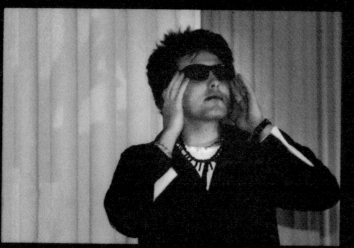
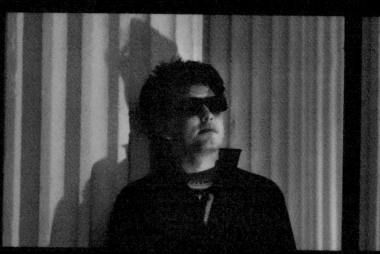

→ 5A → 6 → 6A → 7

in a basement, demos for 'head on the door' london 1984

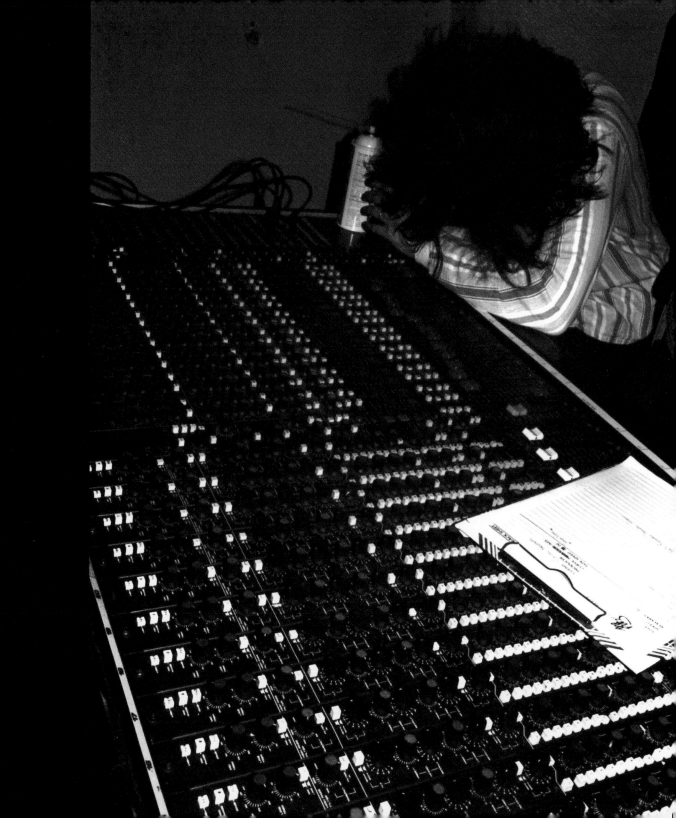

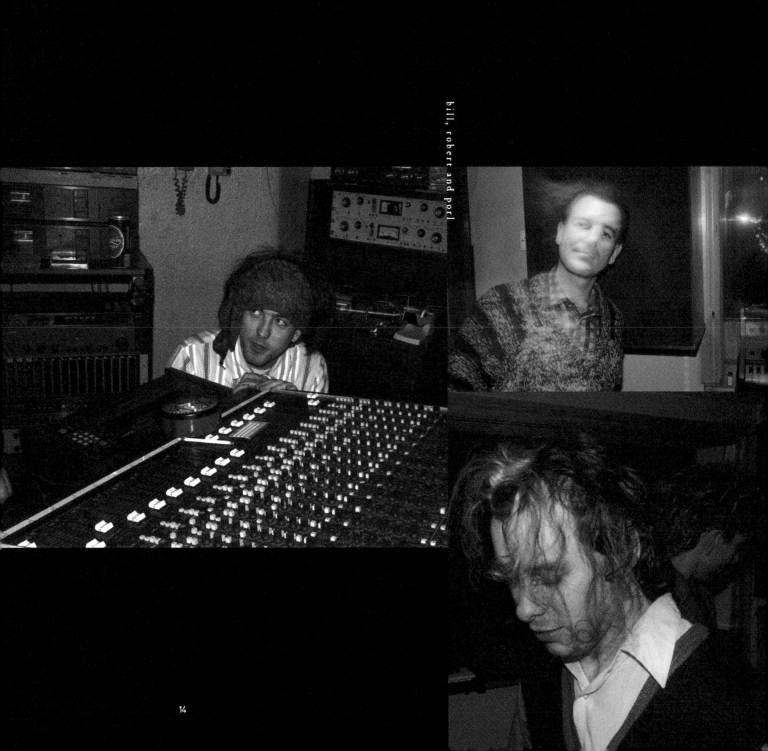

bill, robert and porl

14

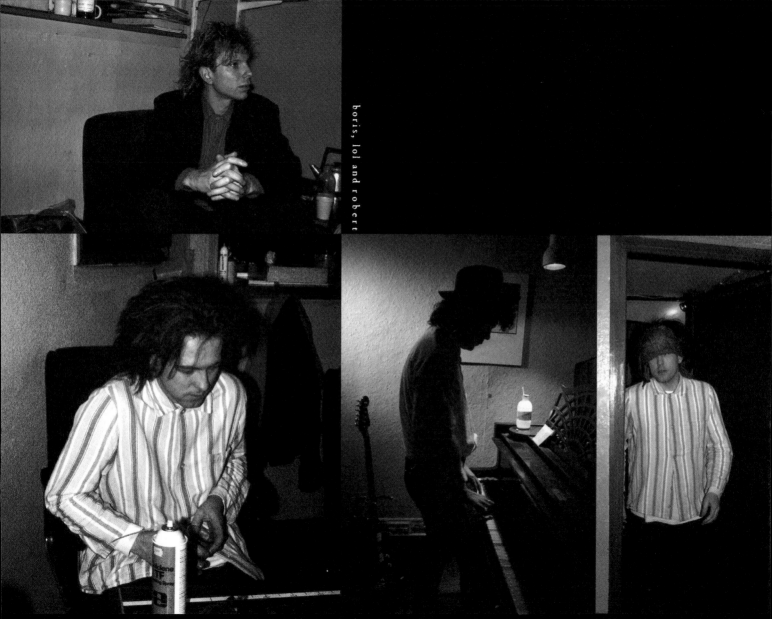

boris, lol and robert

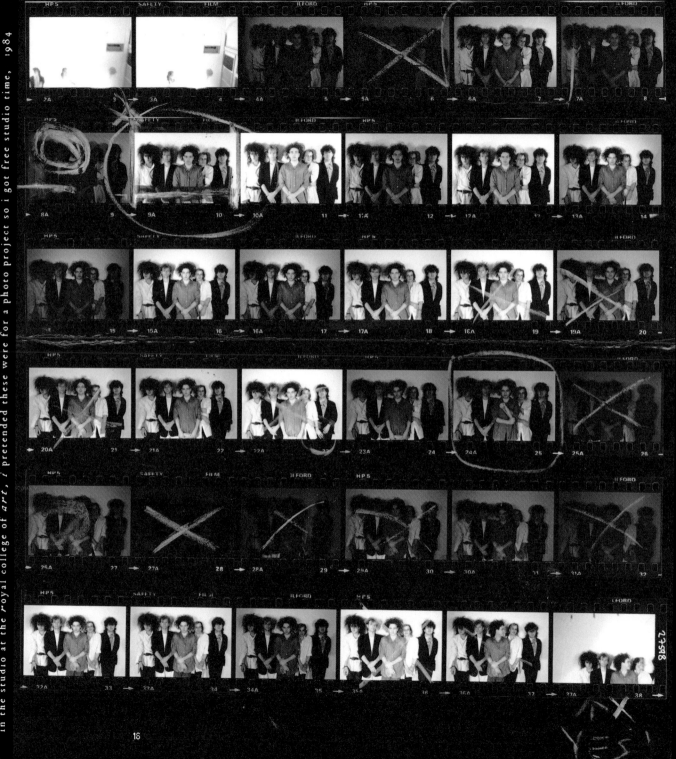

in the studio at the royal college of *art*, i pretended these were for a photo project so i got free studio time, 1984

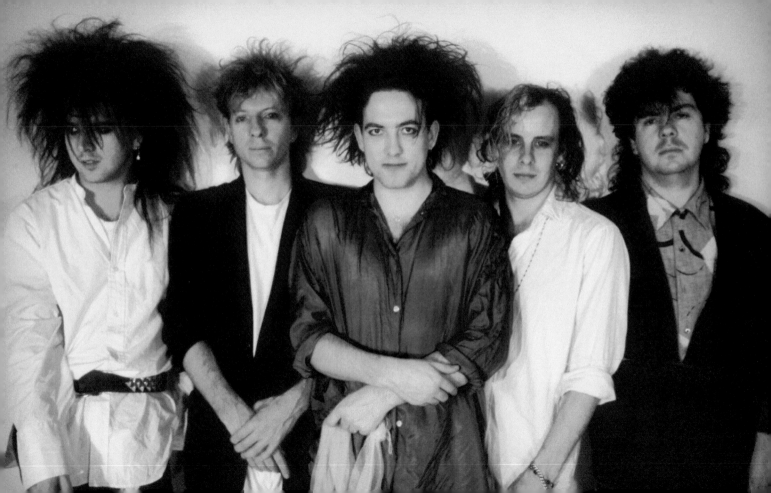

DAYS

video shoot for *inbetween days*, pinewood studios 1985

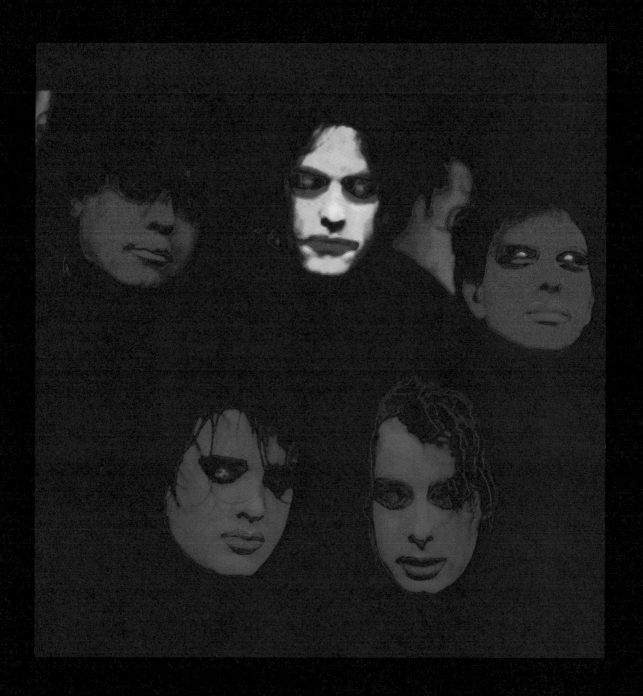

20

p or l

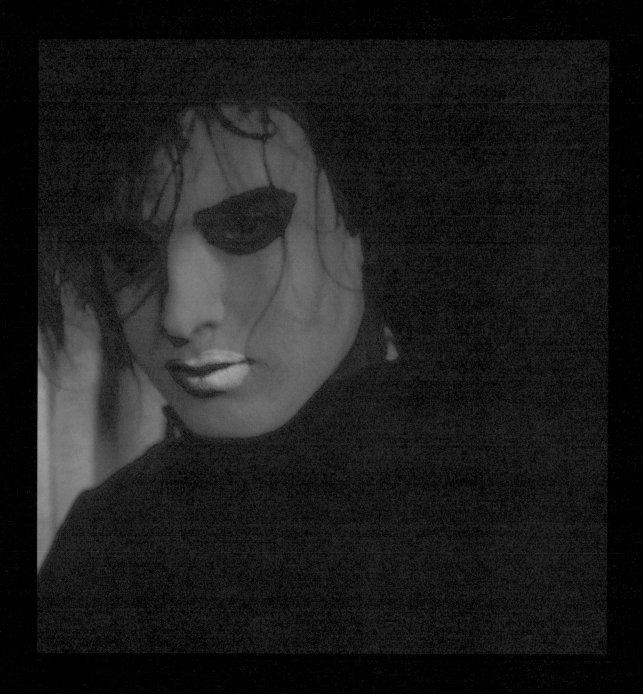

b oris

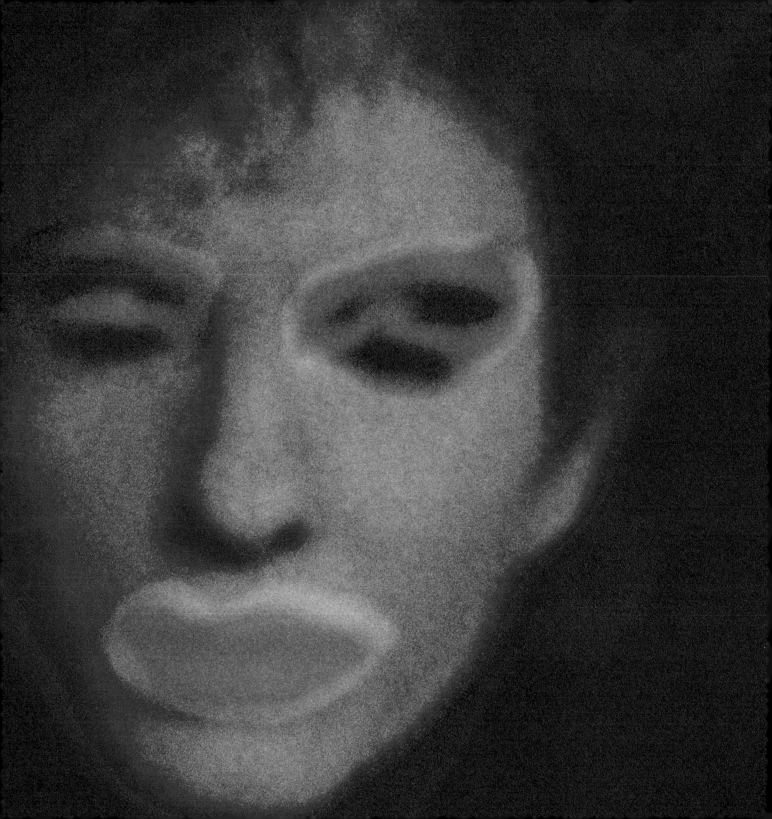

robert

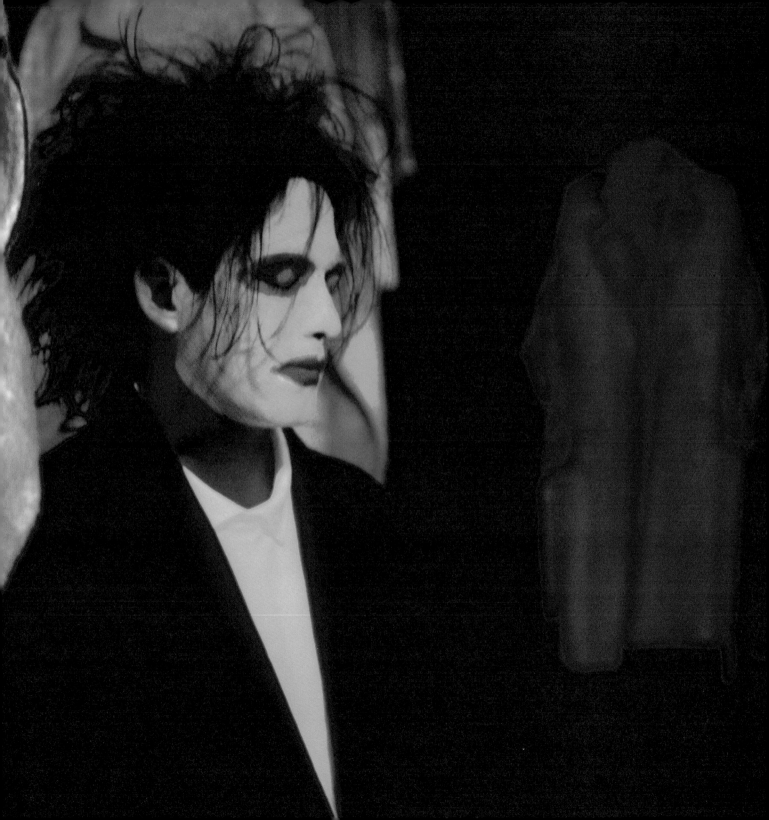

CL O SE

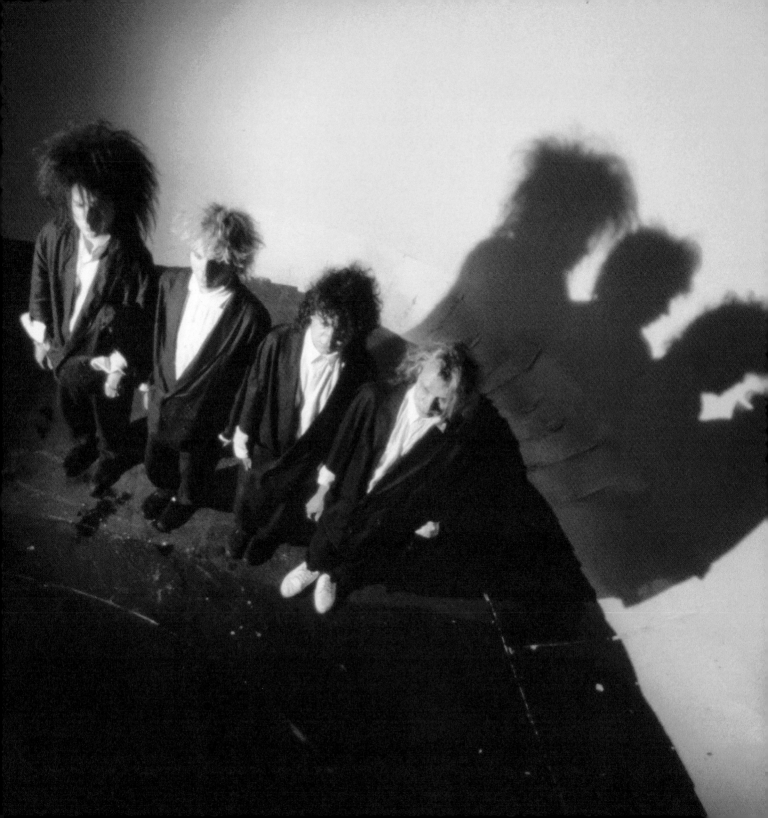

robert just before being submerged in water

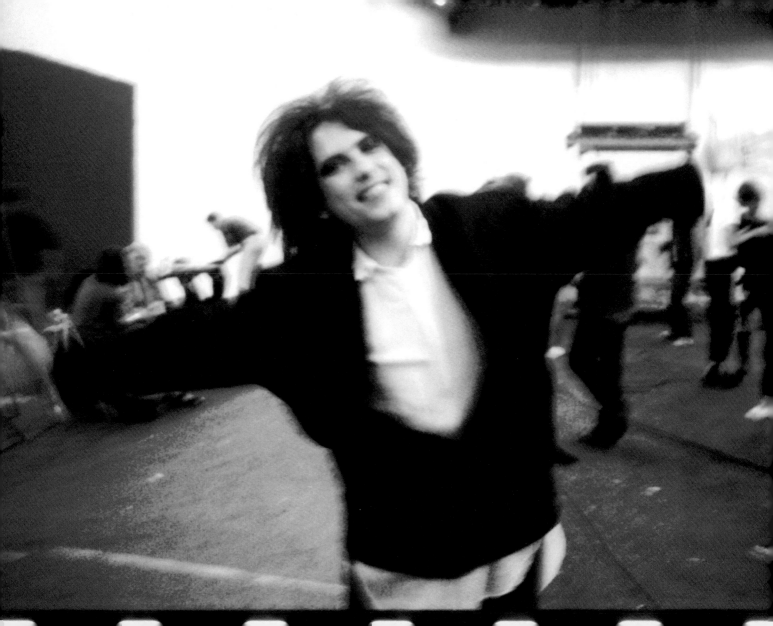

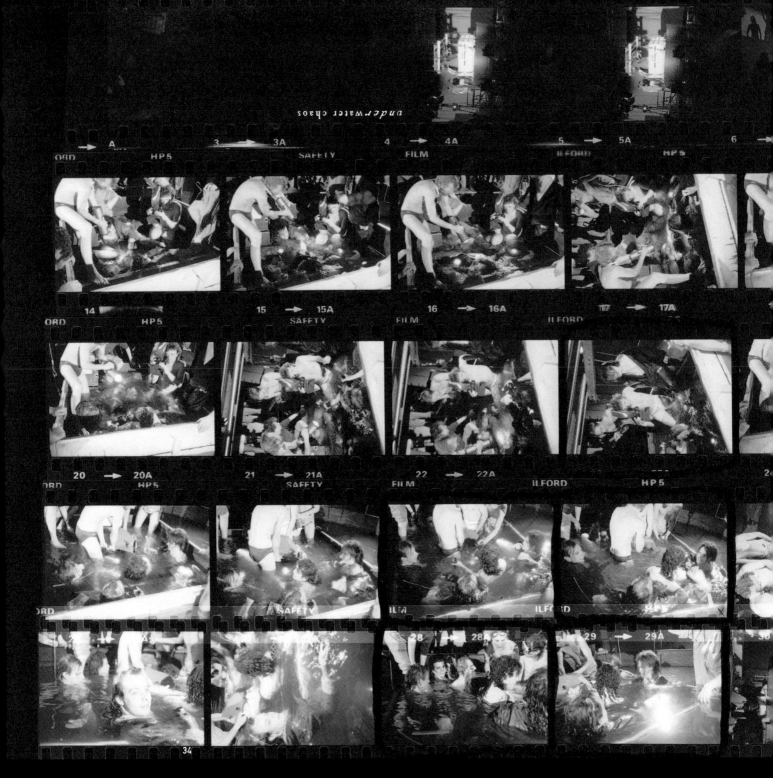
underwater chaos

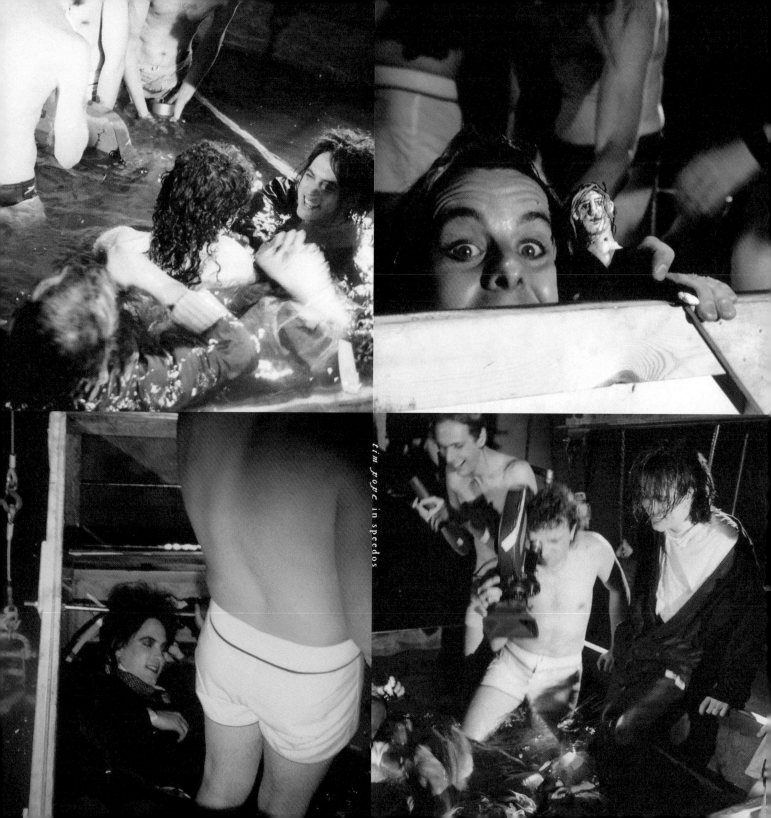

tim pope in speedos

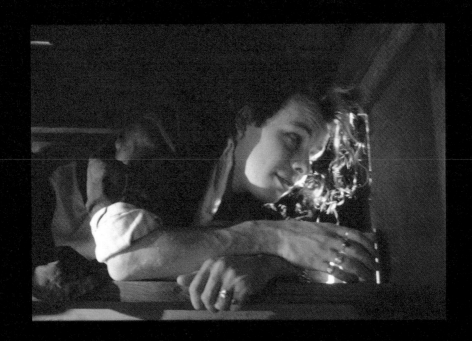

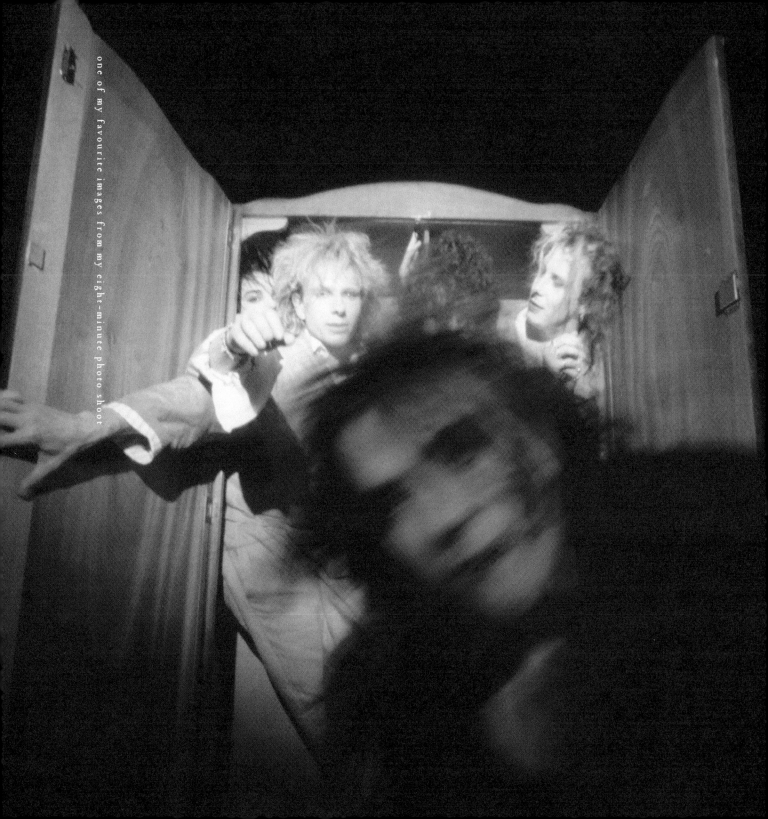

33

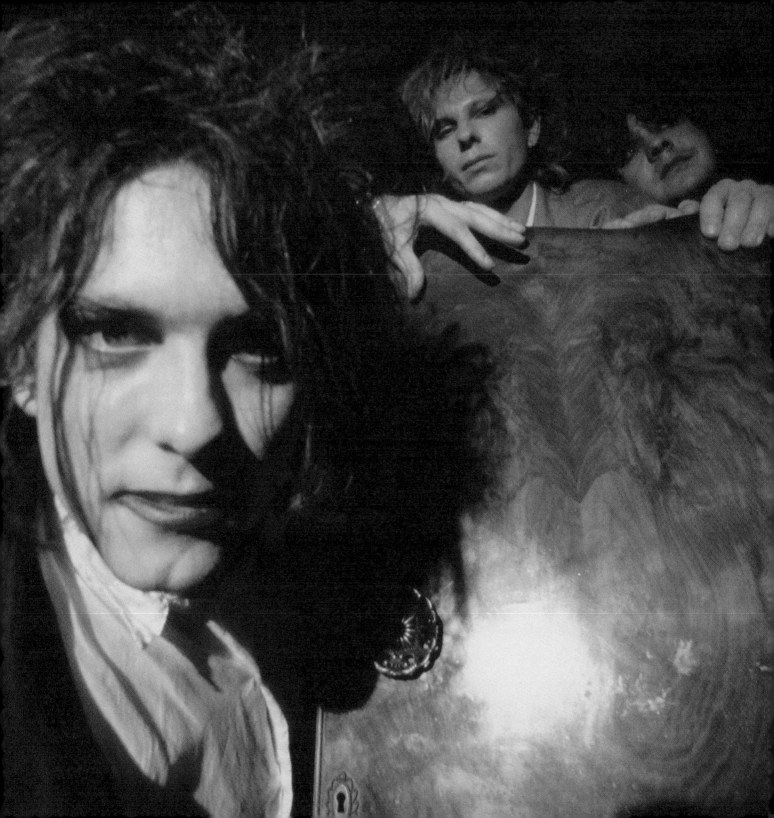

bathed in red at the camden palace london

1985

video shoot, a night like this, london, 1986

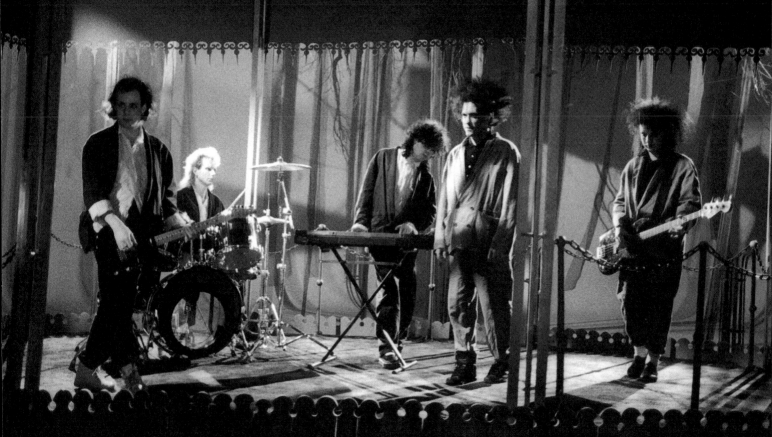

tim very kindly lent me the band for five and a half minutes to grab a few snaps

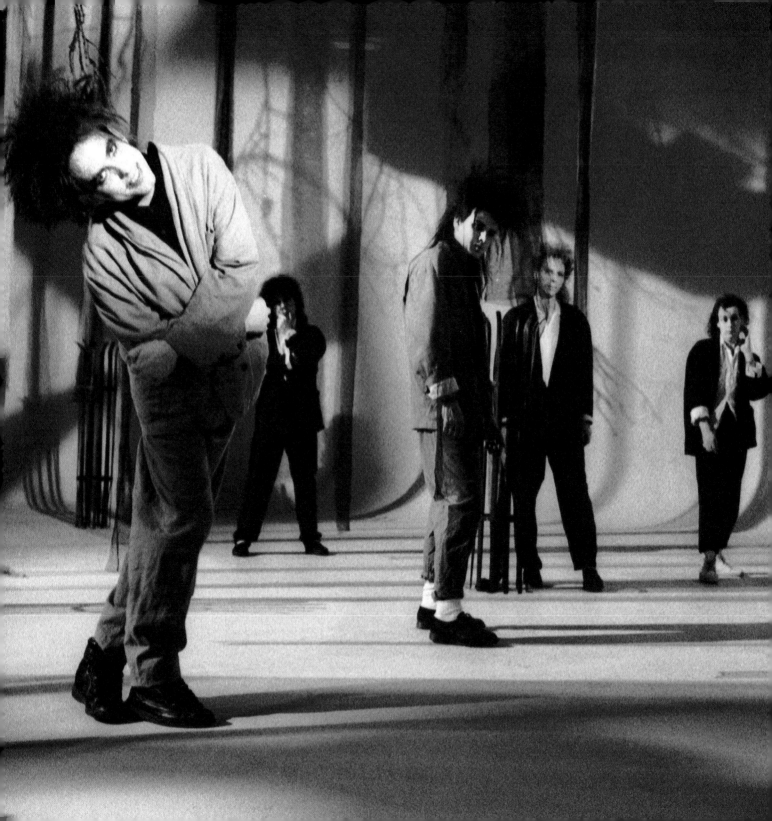

CRY *video* shoot, boys don't cry, london 1986

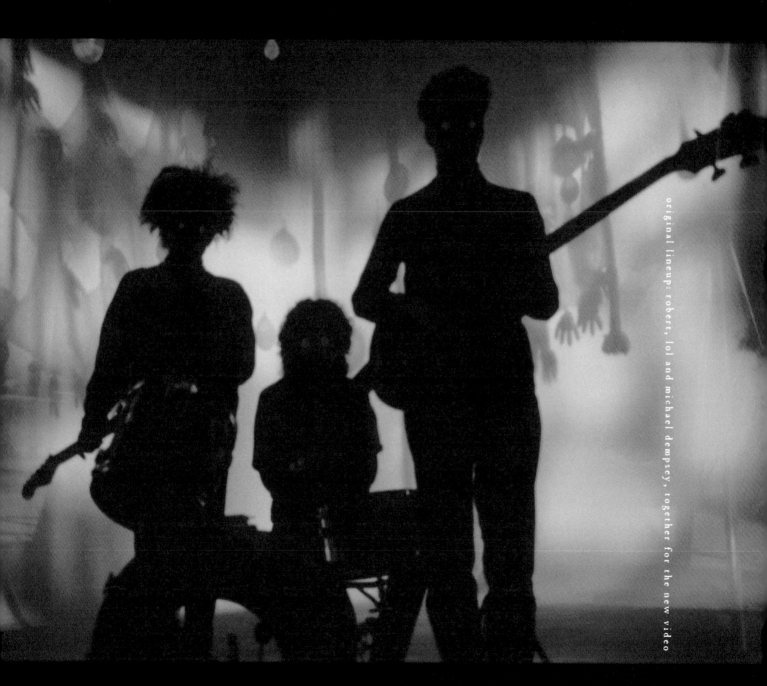

original lineup: robert, lol and michael dempsey, together for the new video

infin ity

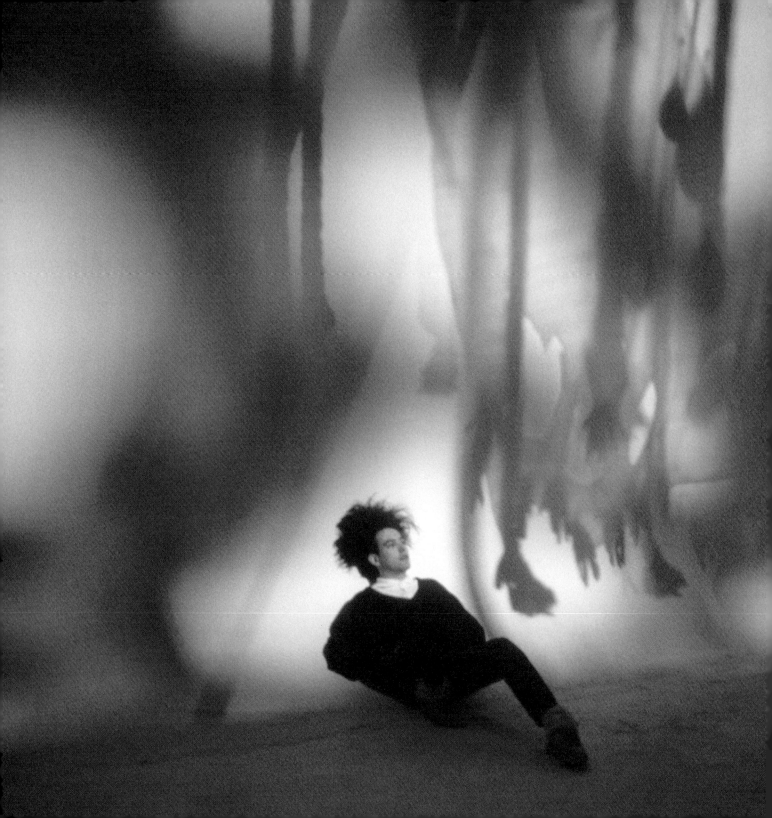

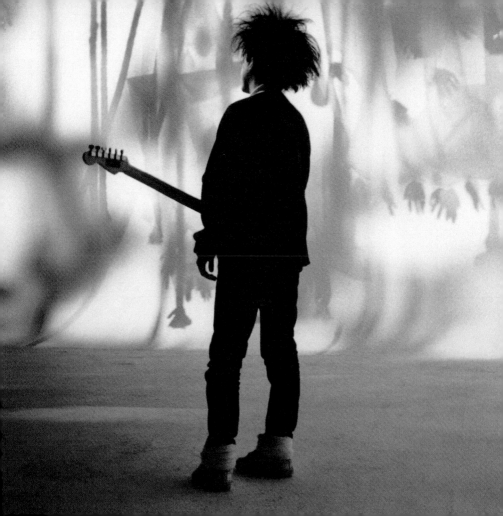

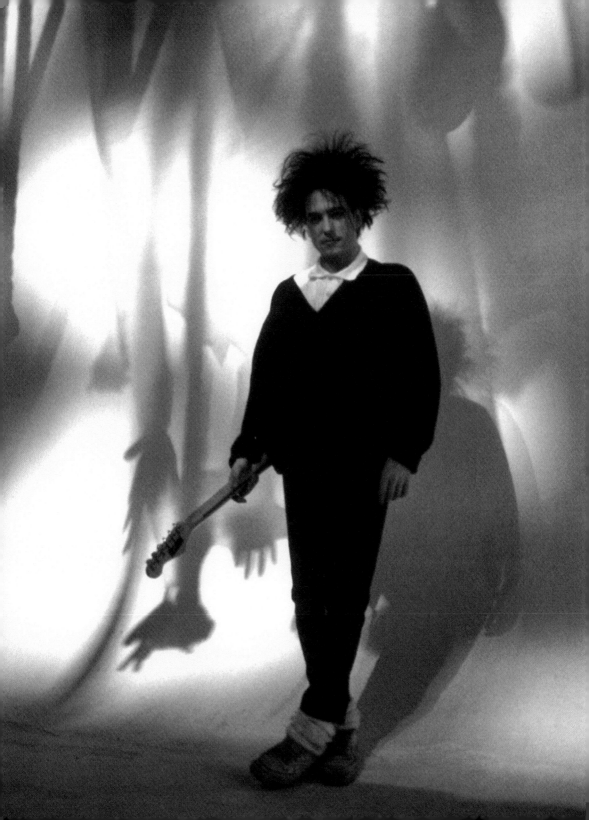

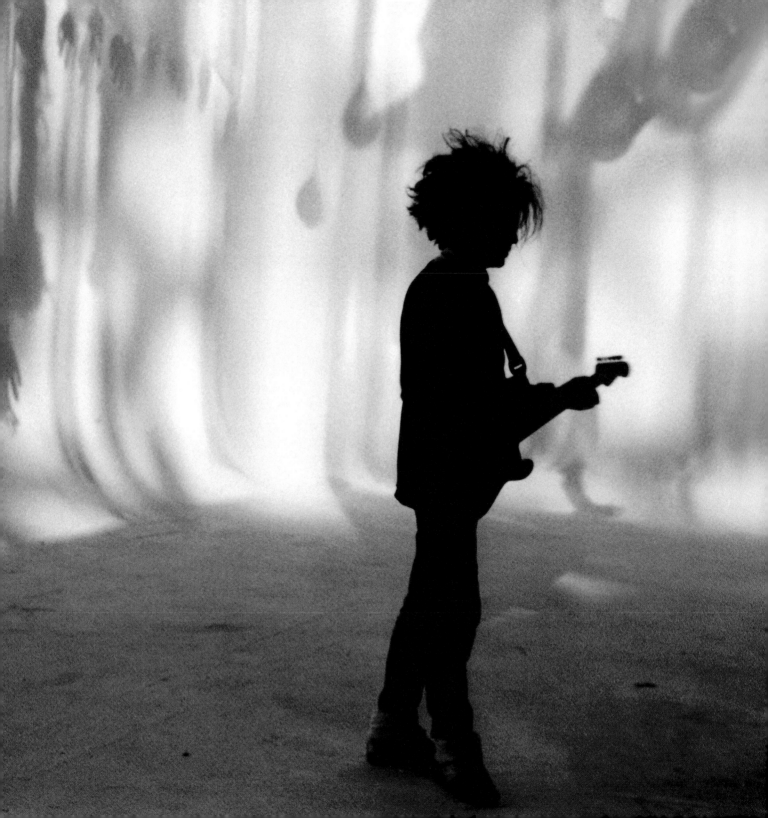

video shoot, why can't i be you?, london 1987

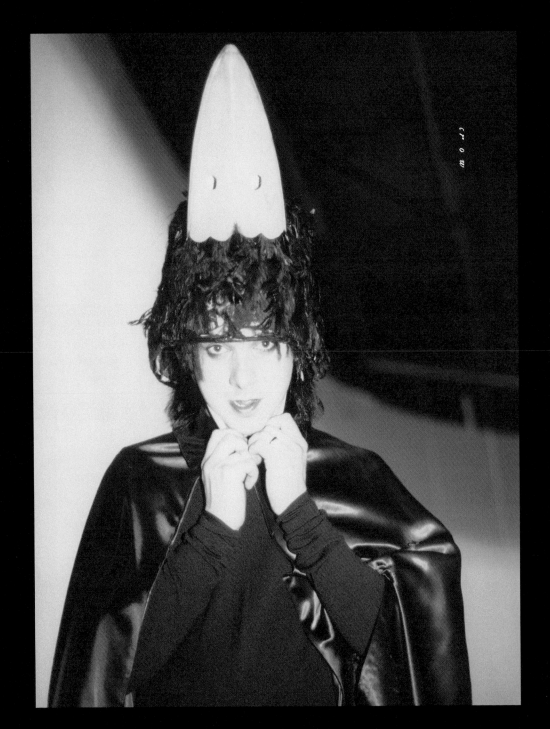

crow

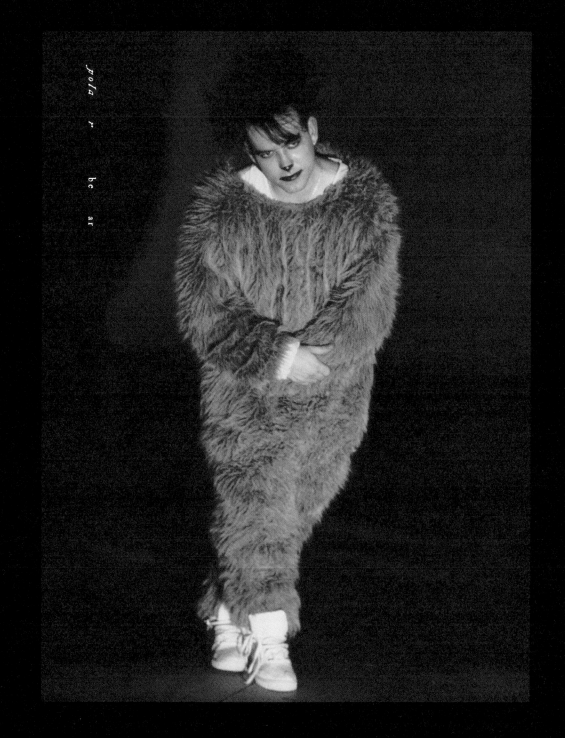

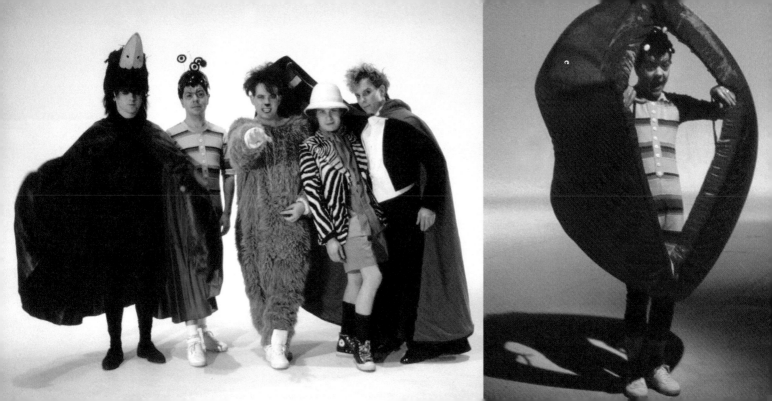

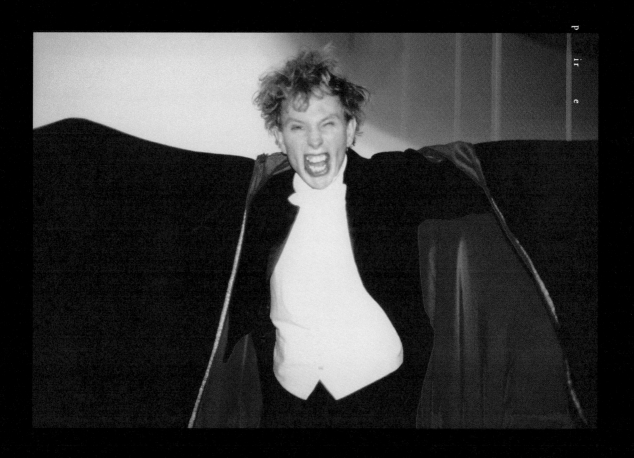

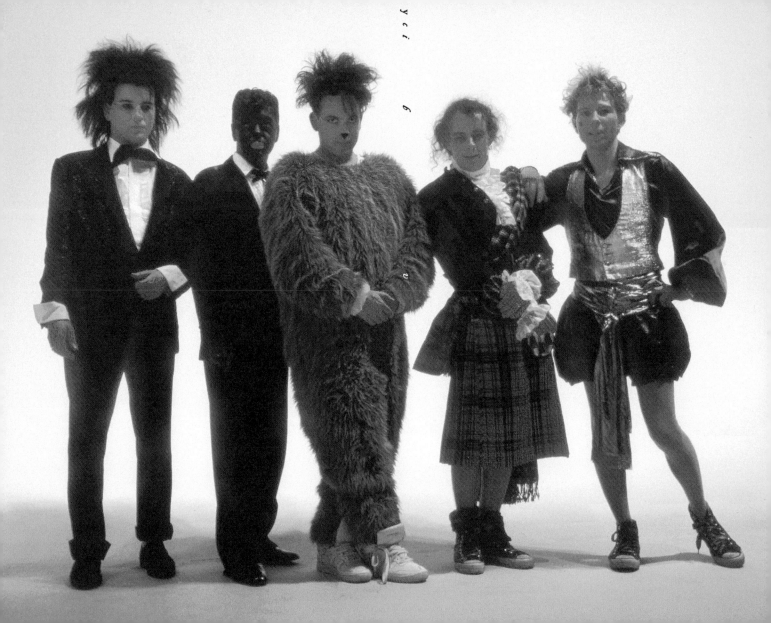

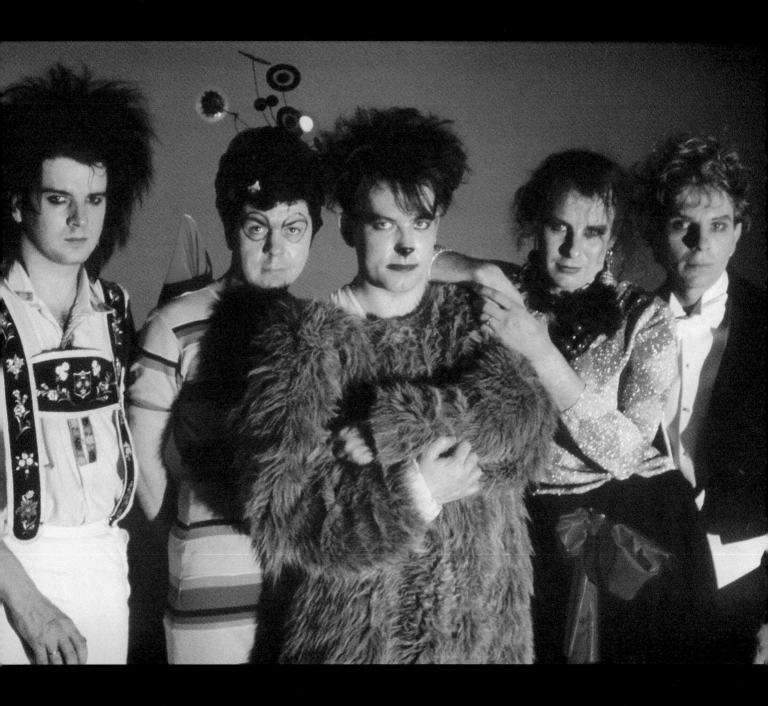

press session, rio

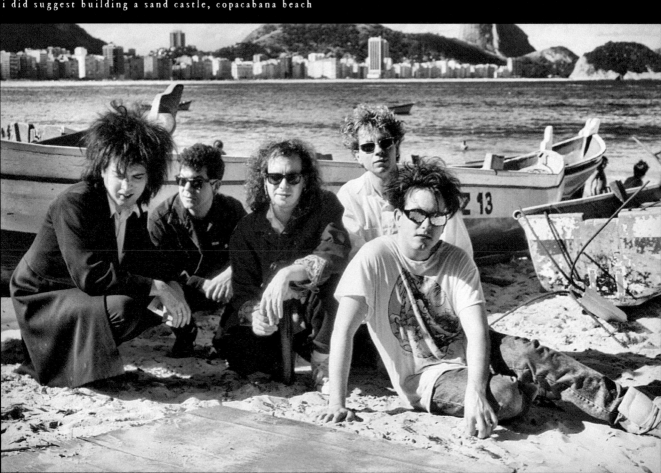

i did suggest building a sand castle, copacabana beach

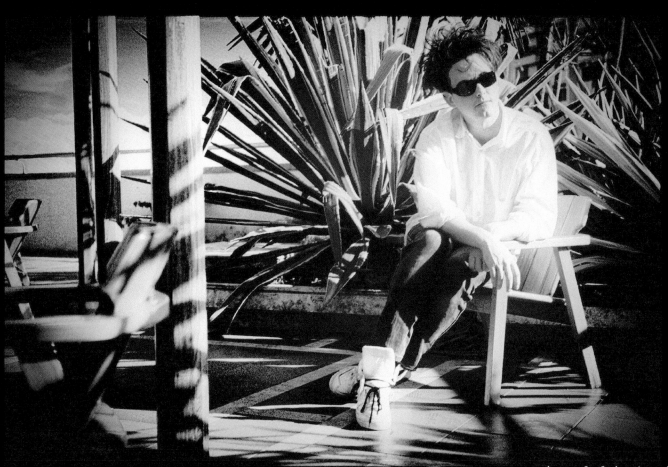

on the roof of the rio palace

the K K

I S S

S ing tour, north america 1987

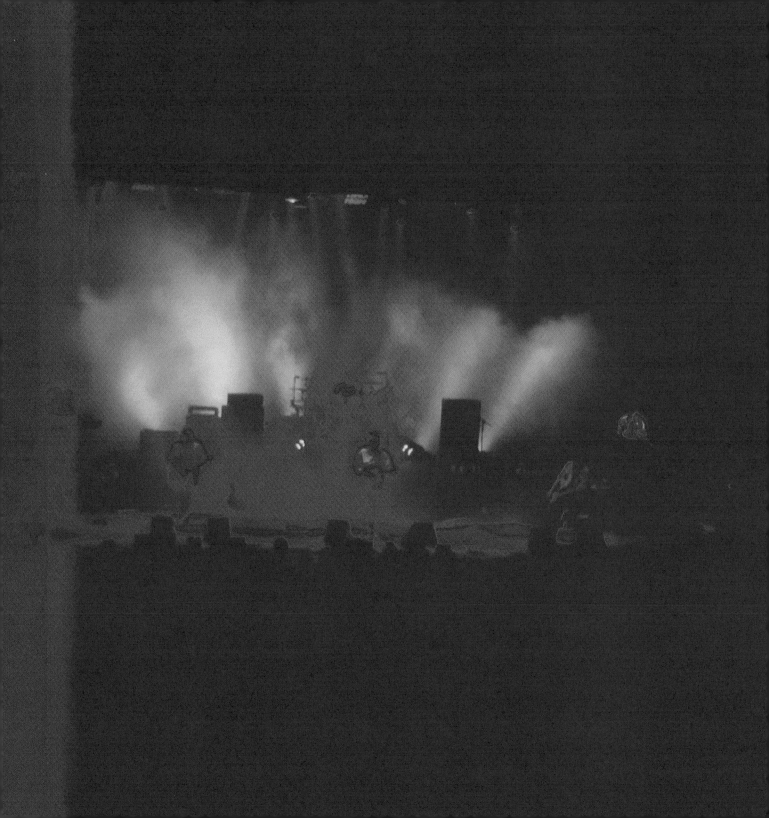

i had originally ear-marked these for the just like *heaven* single sleeve ...

p hi l adel p h ia smoking

the inked potato took over

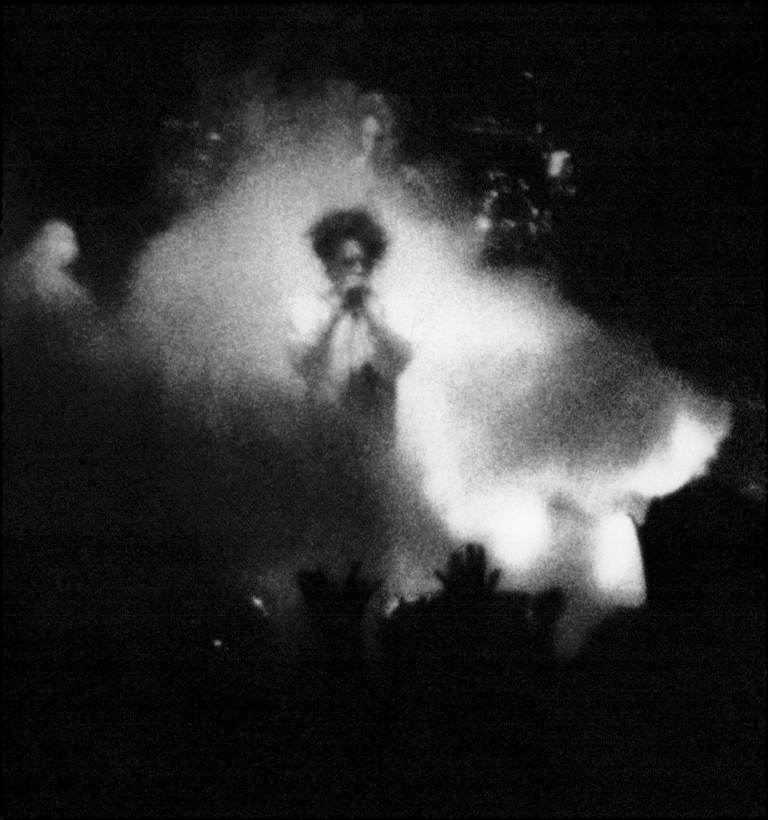

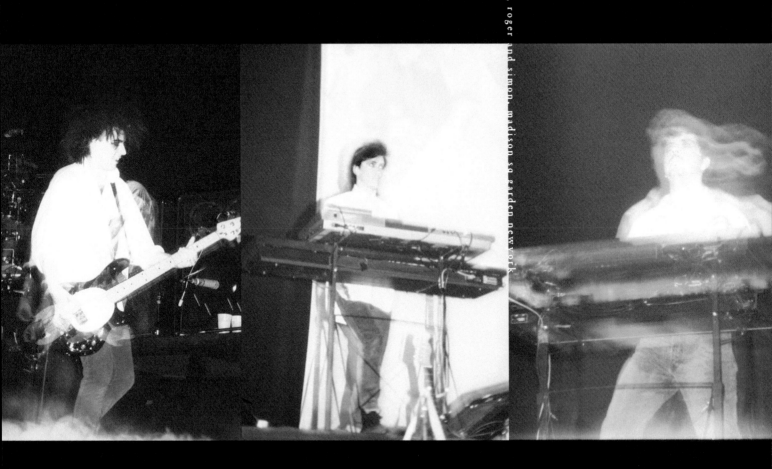

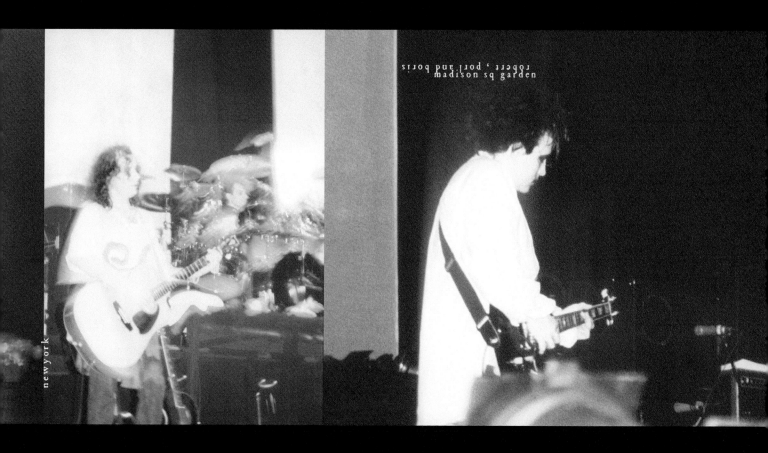

newyork

madison sq garden
robert , port and boris

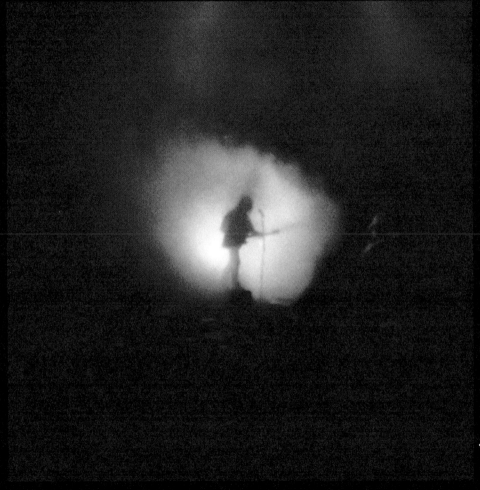

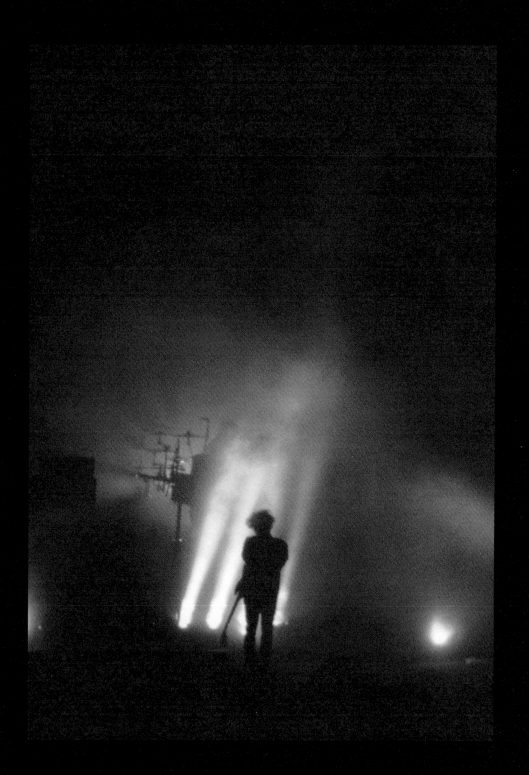

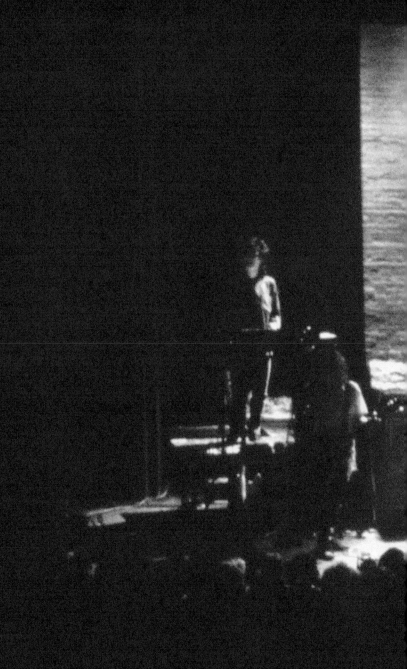

after playing madison sq garden, an intimate gig at *the ritz* newyork

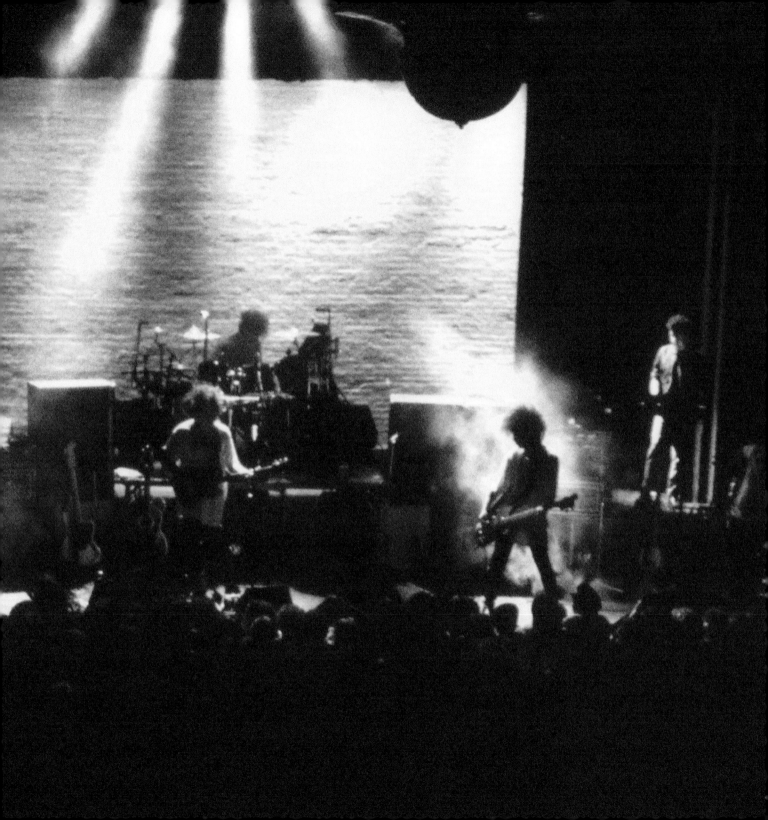

ju S
 t

video shoot, london 1987 like

ɥ

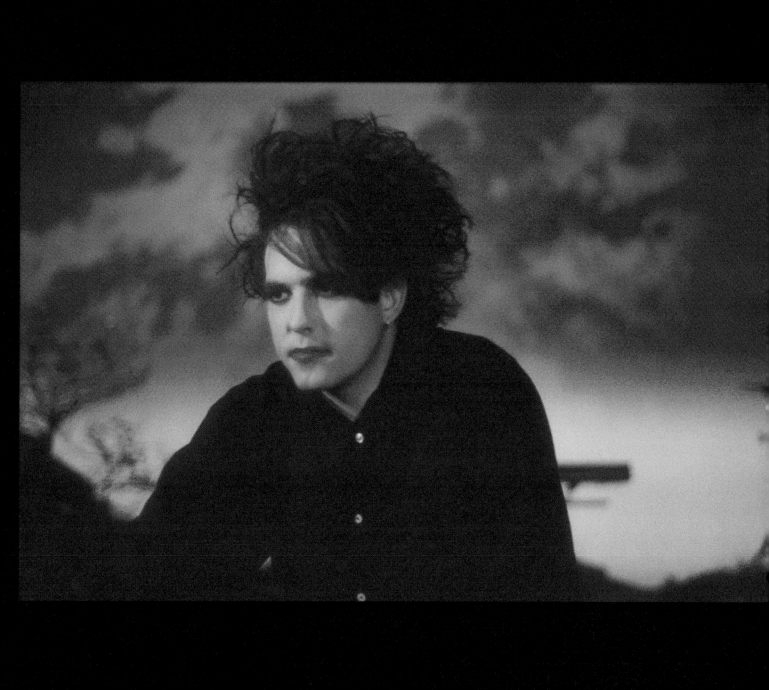

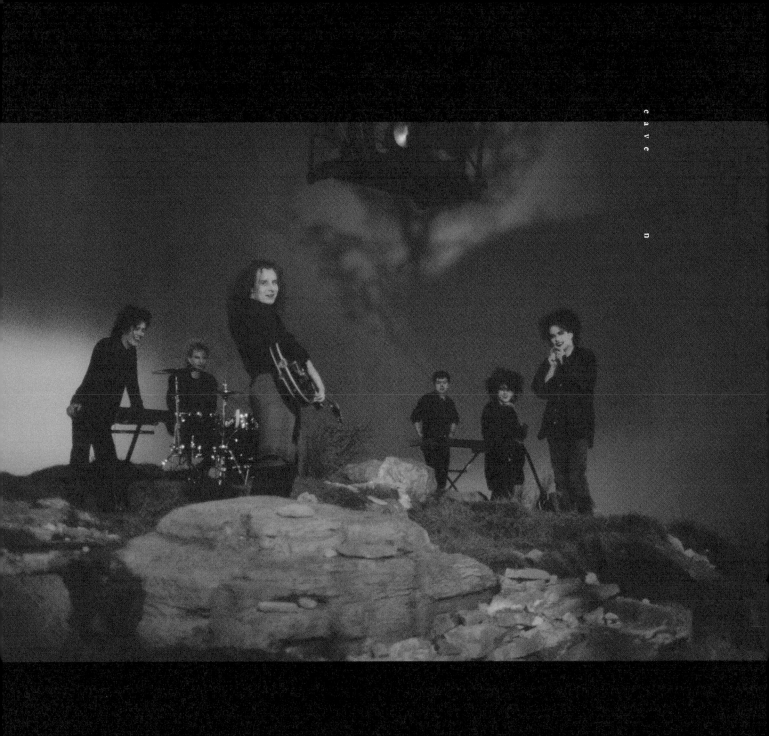

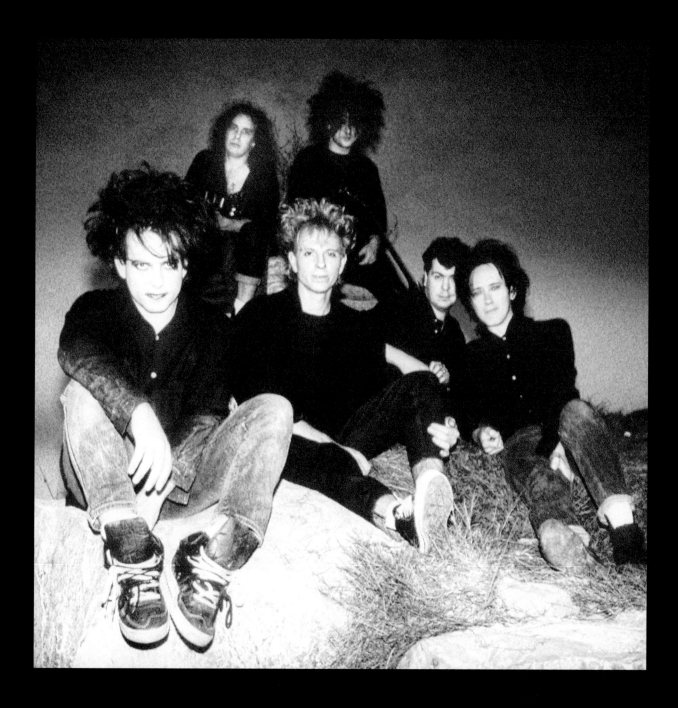

robert

painted 1987

30

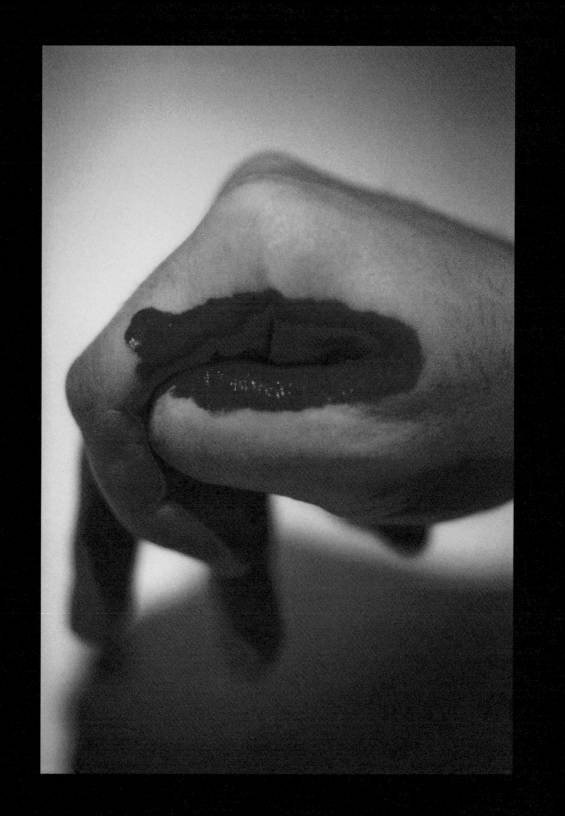

ORANG
E

session of polaroids for the fanclub, shot in southern ireland whilst creat

ing cure in orange art

87
19

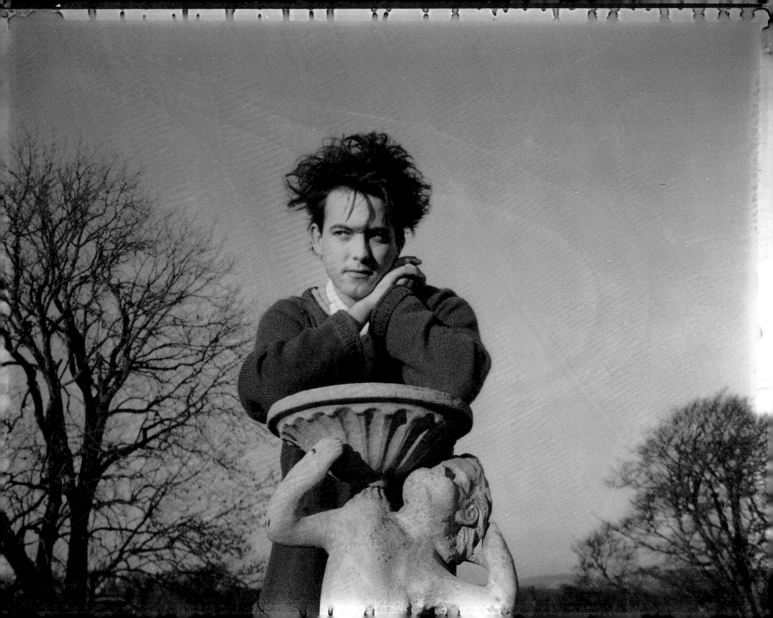

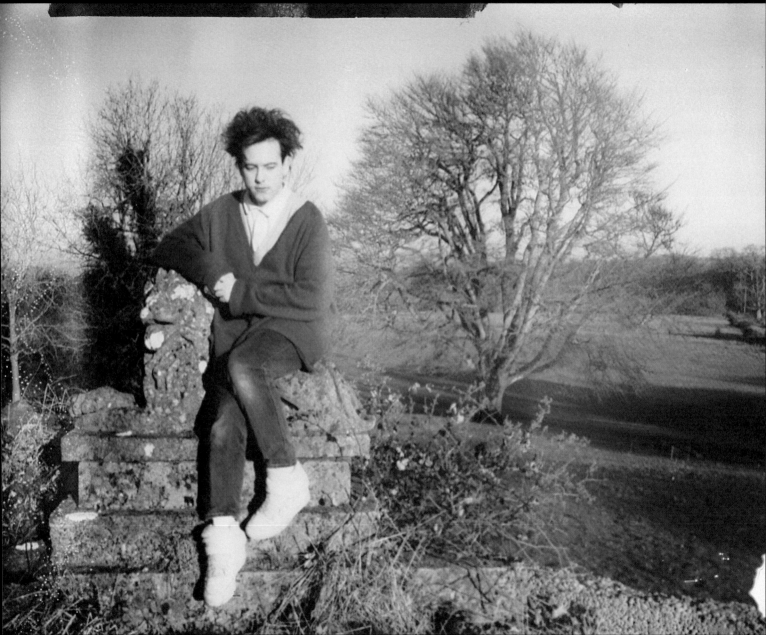

in the castle. i love the colour and softness of this polaroid transparency film.

after this it was decided that this was the film to be used for the

disintegration cover.

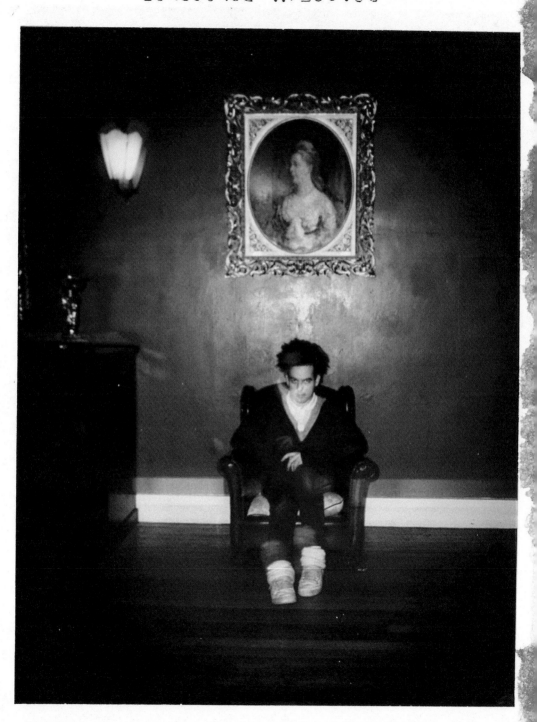

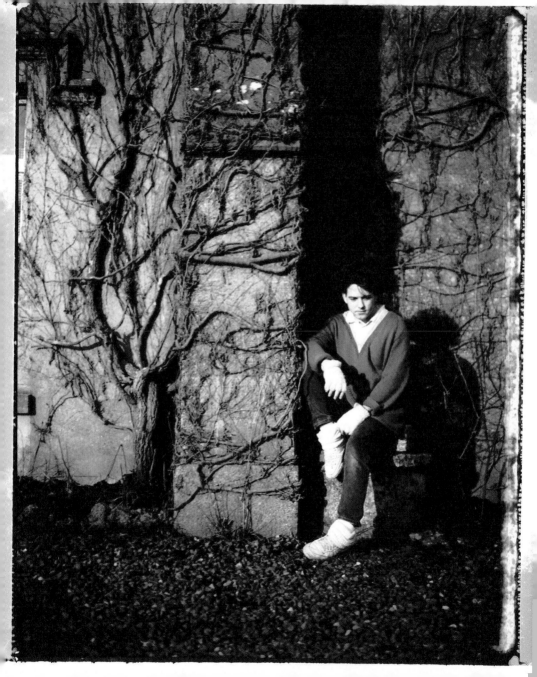

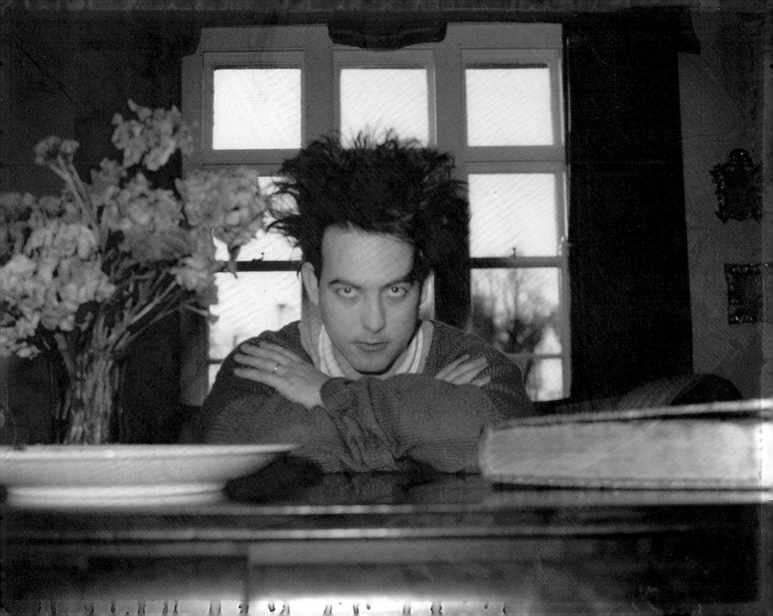

video shoot, hot hot hot!!! 1988

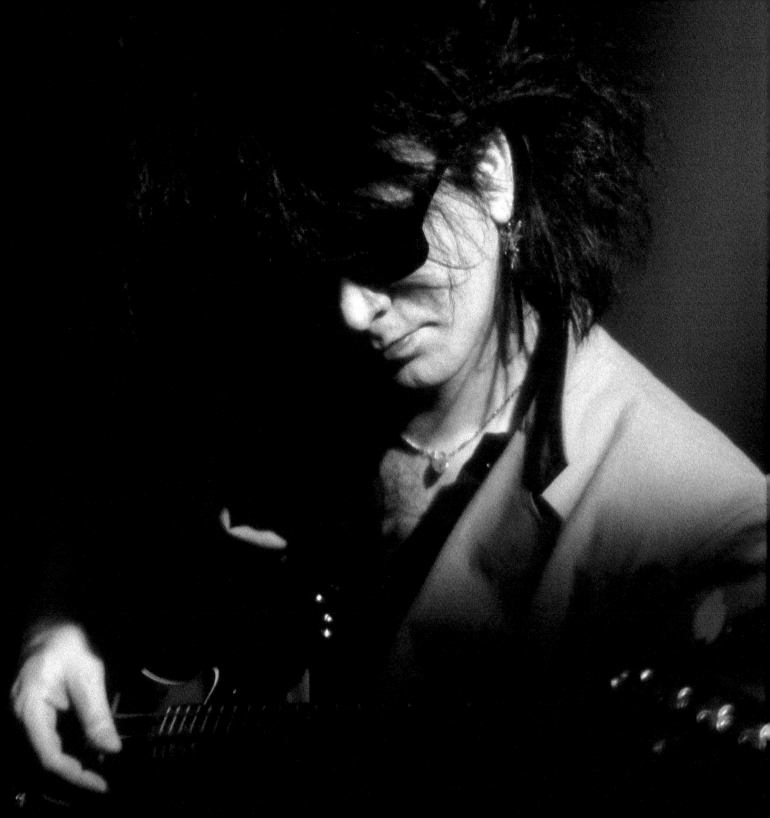

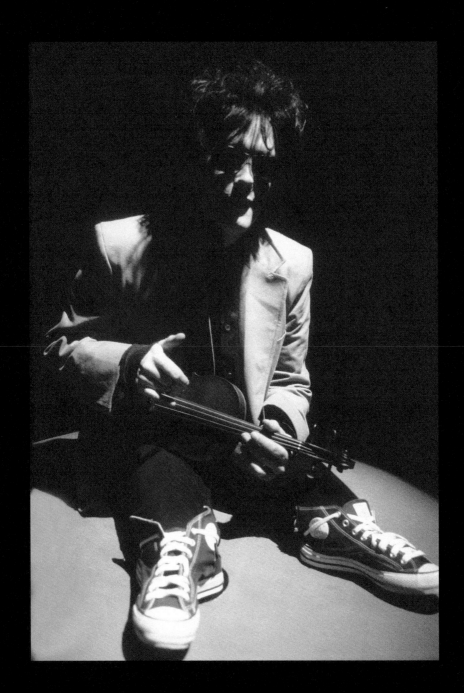

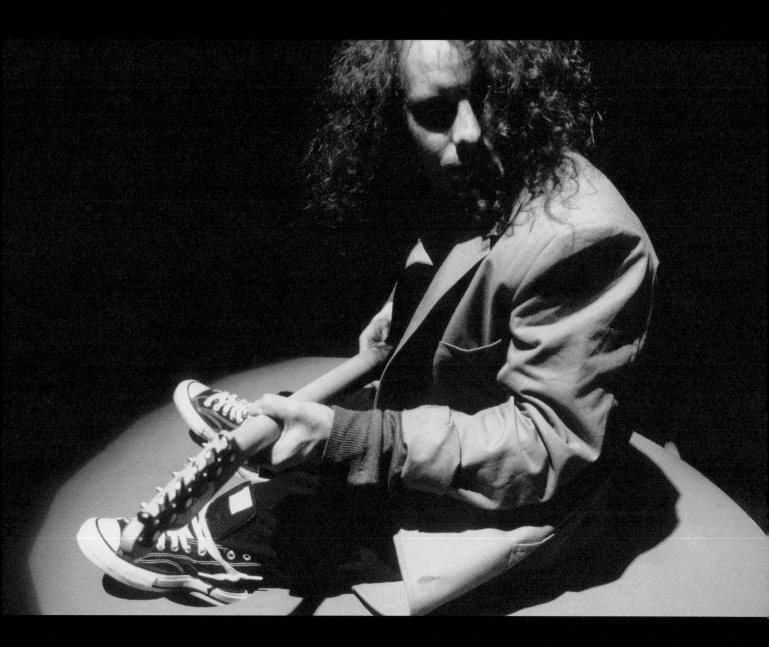

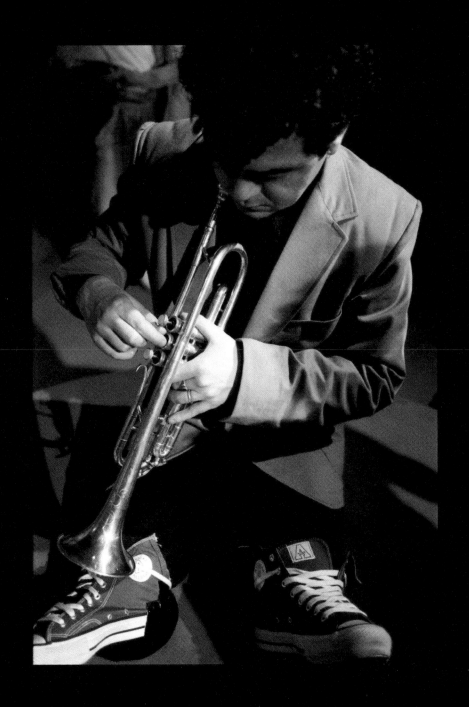

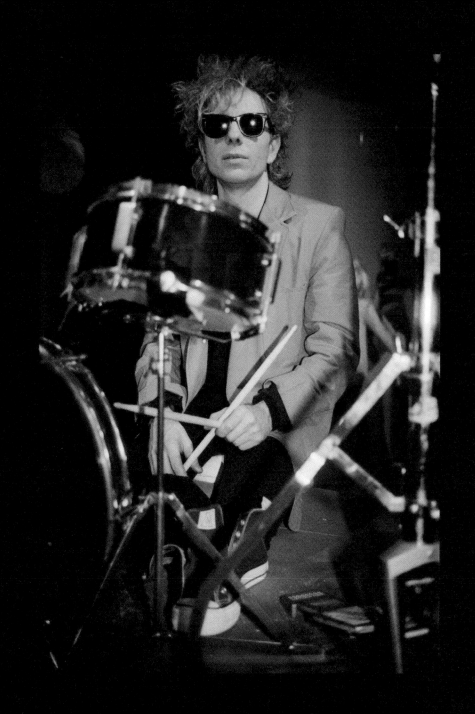

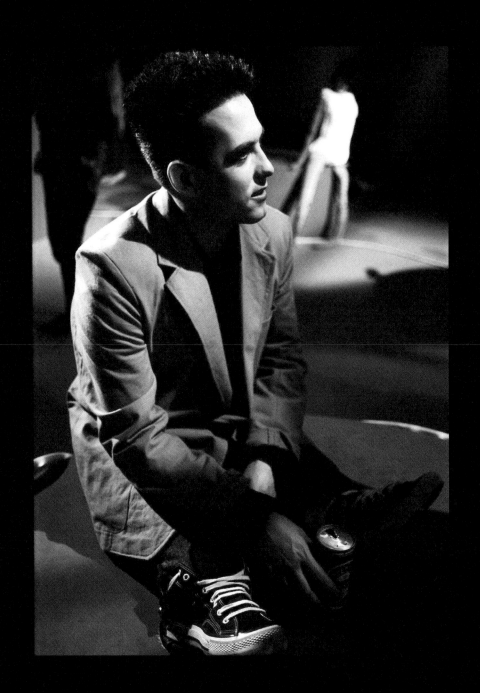

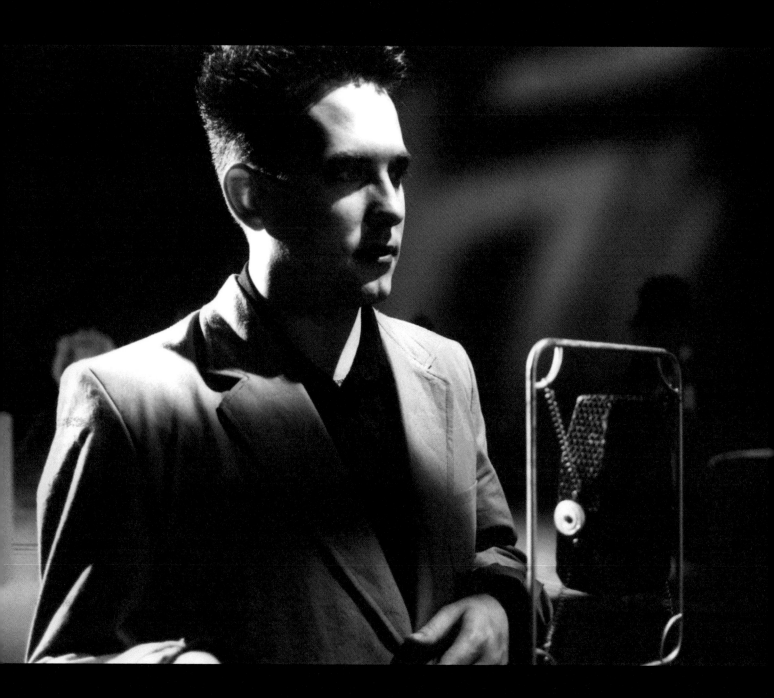

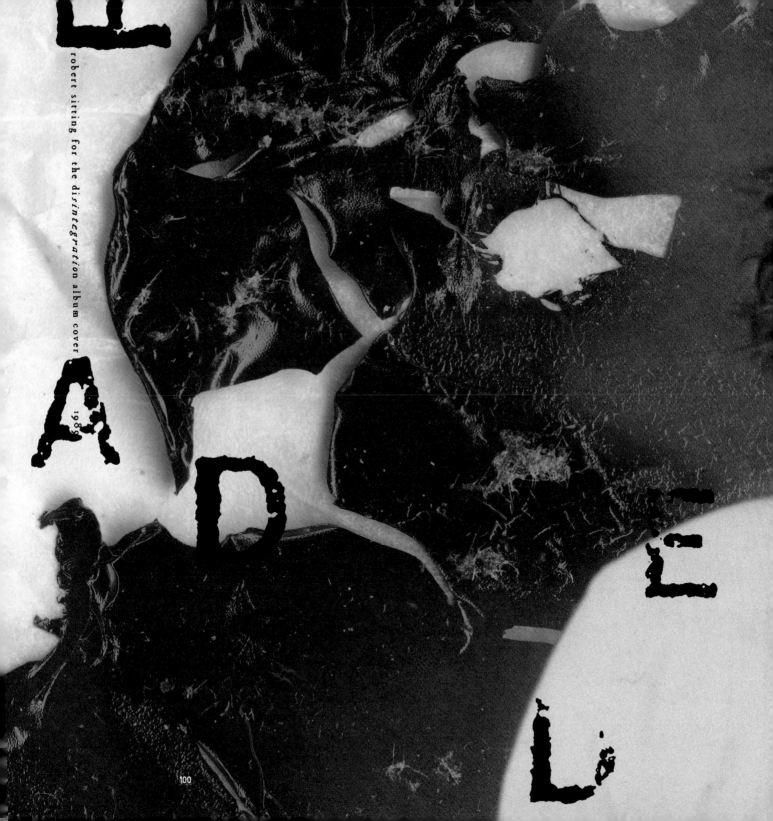

robert sitting for the *disintegration* album cover 1989

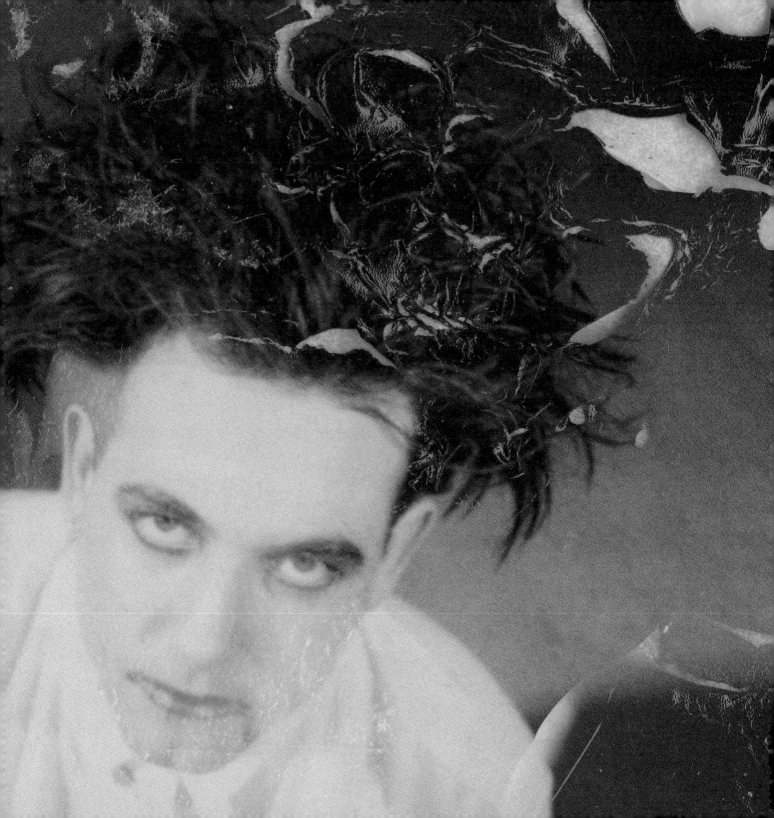

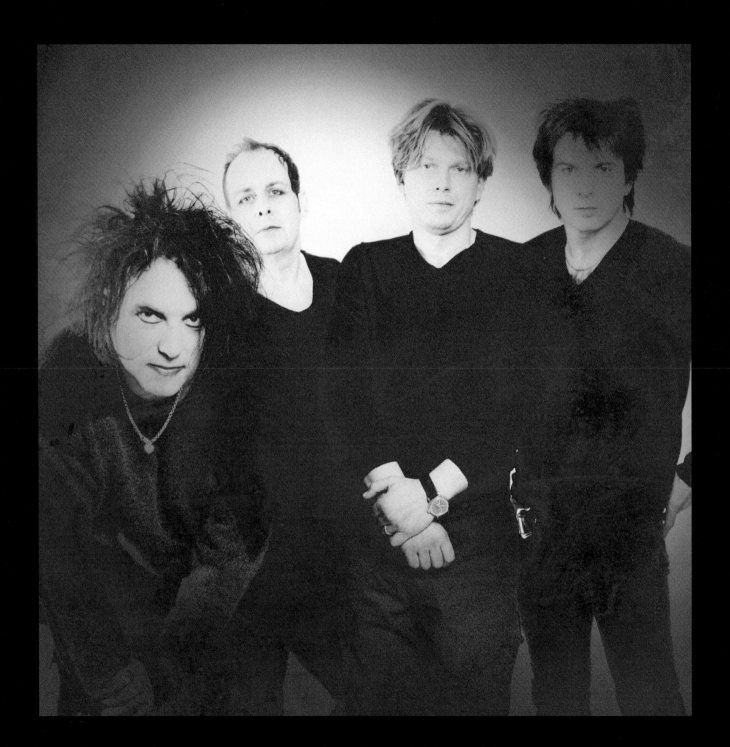

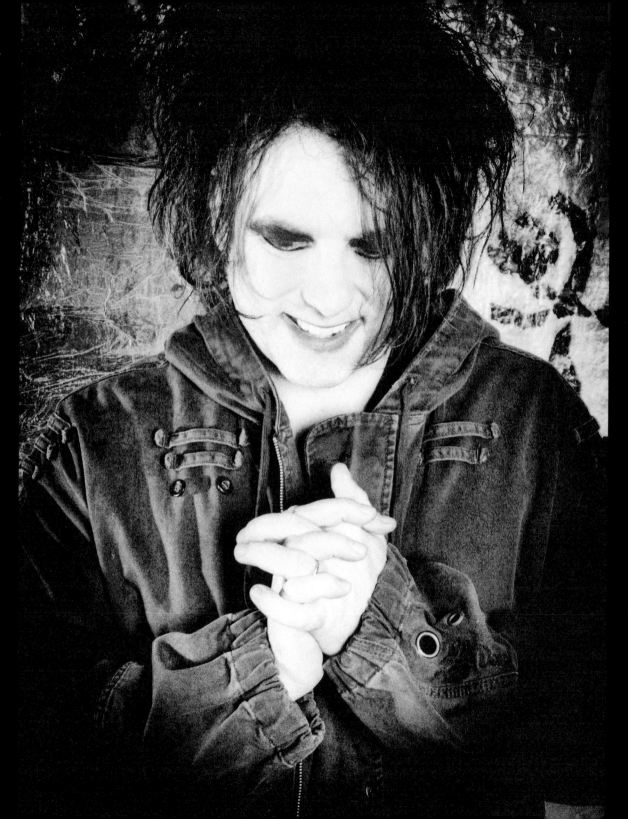

after several years shooting fashion and playing with my banjo. royal albert hall show promo session

2006

teenage cancer trust, royal albert

london, 2oo6

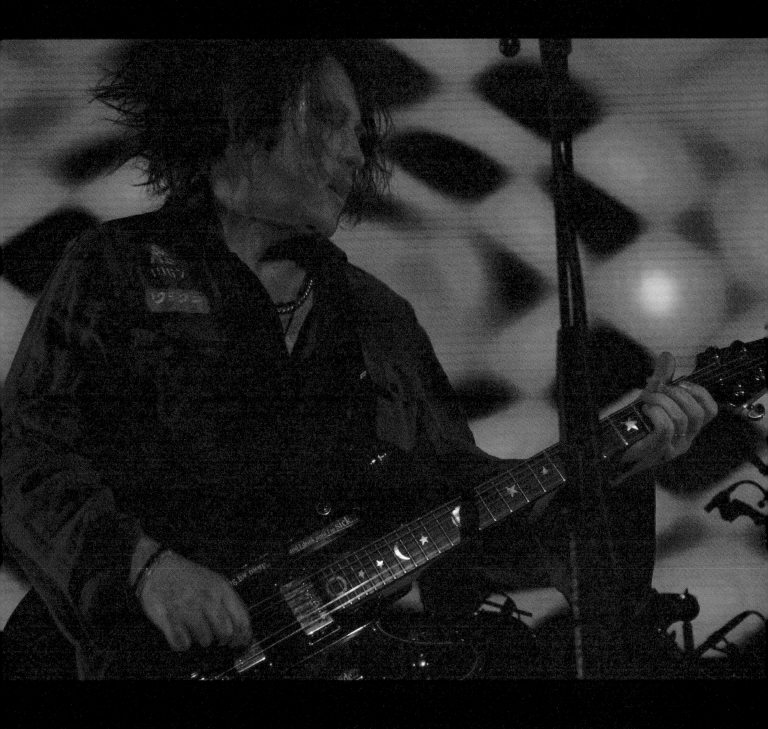

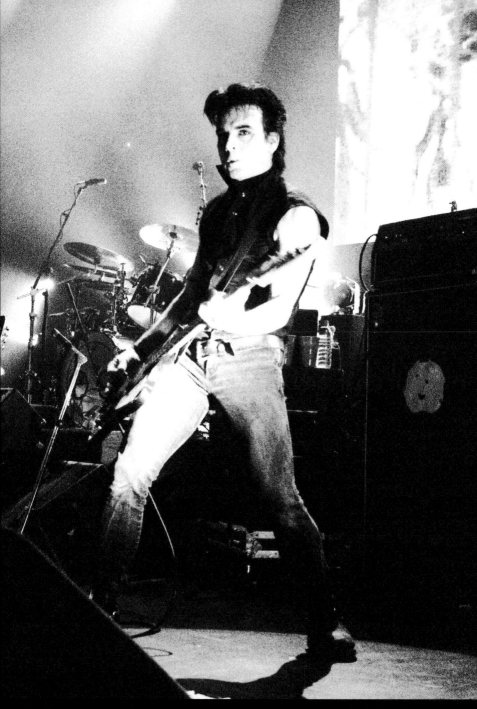

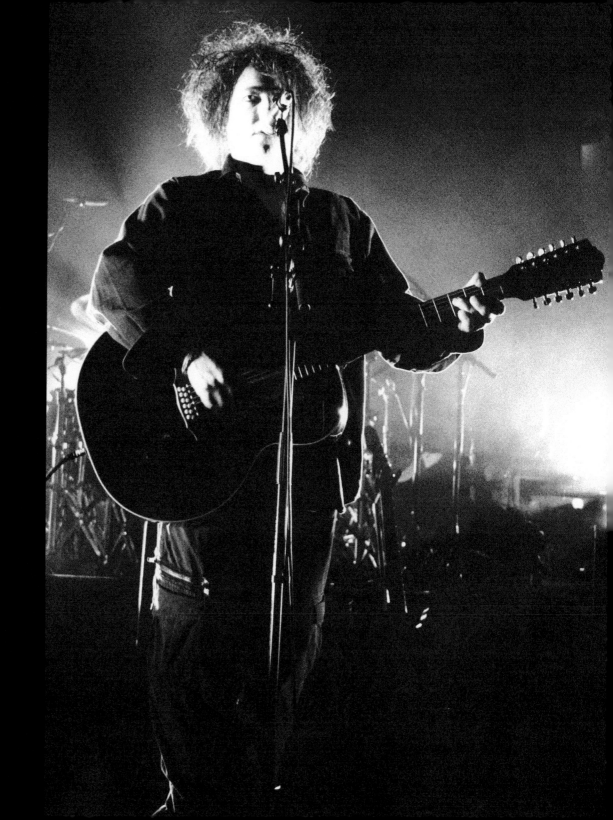

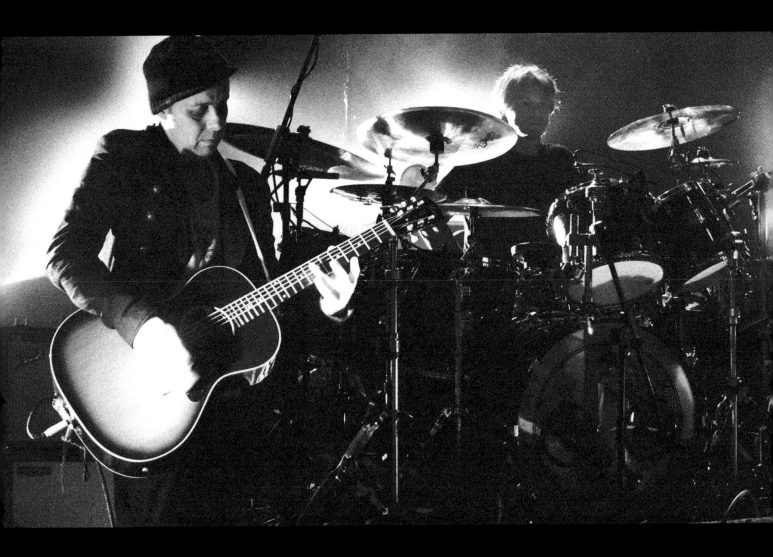

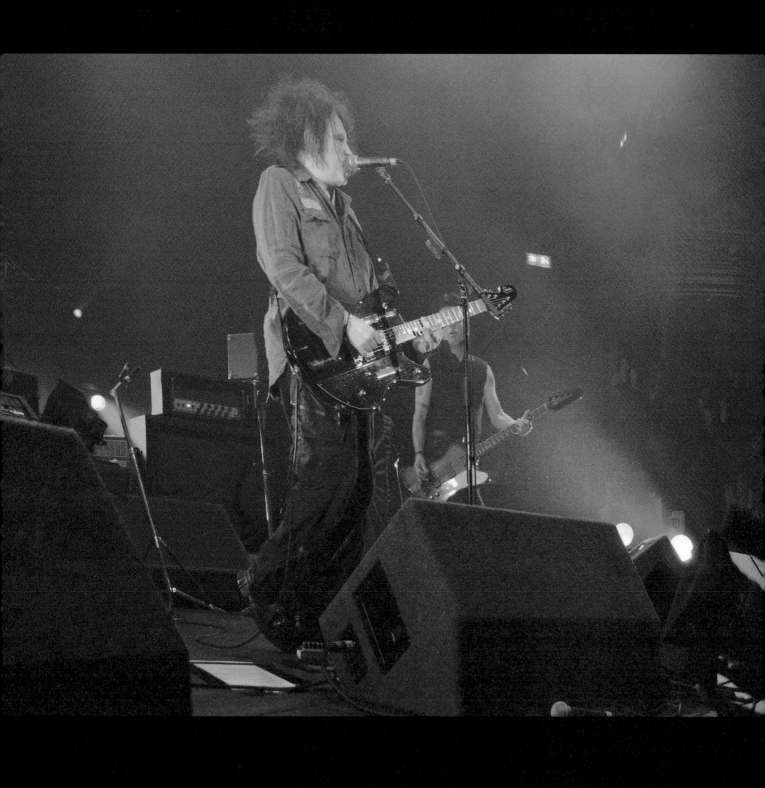

GHOST

in the *studio* recording 4:13 dream, sussex 2007

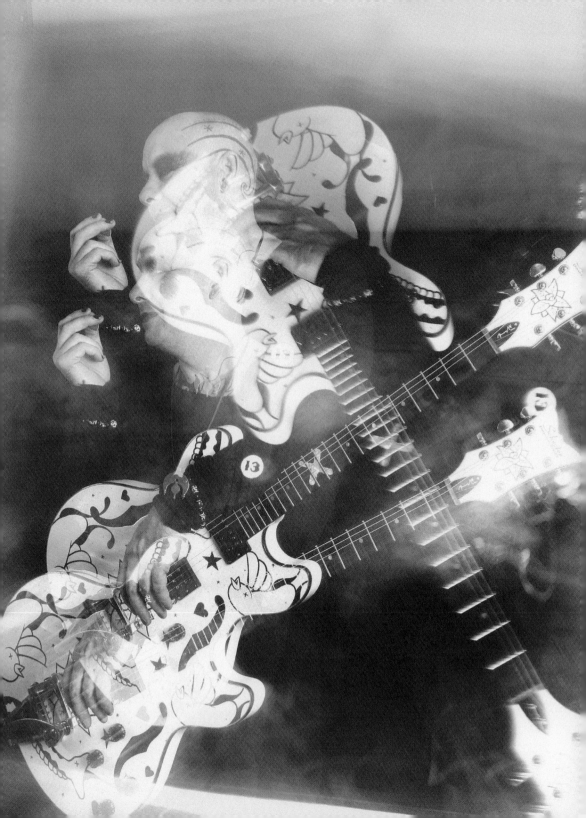

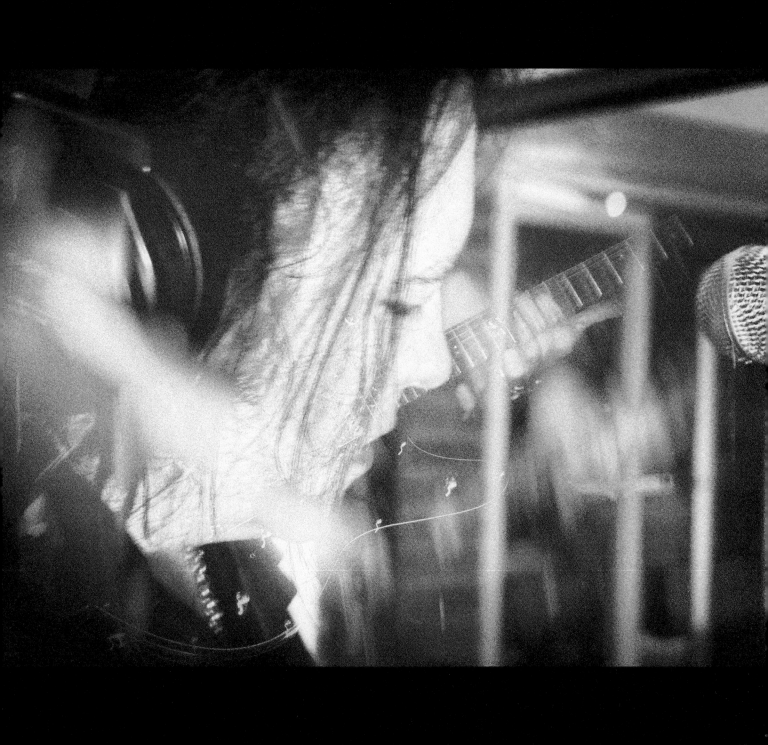

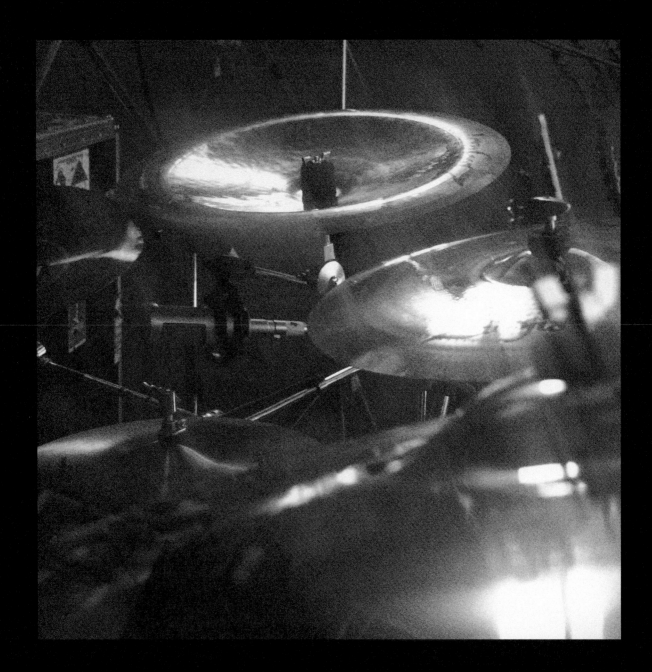

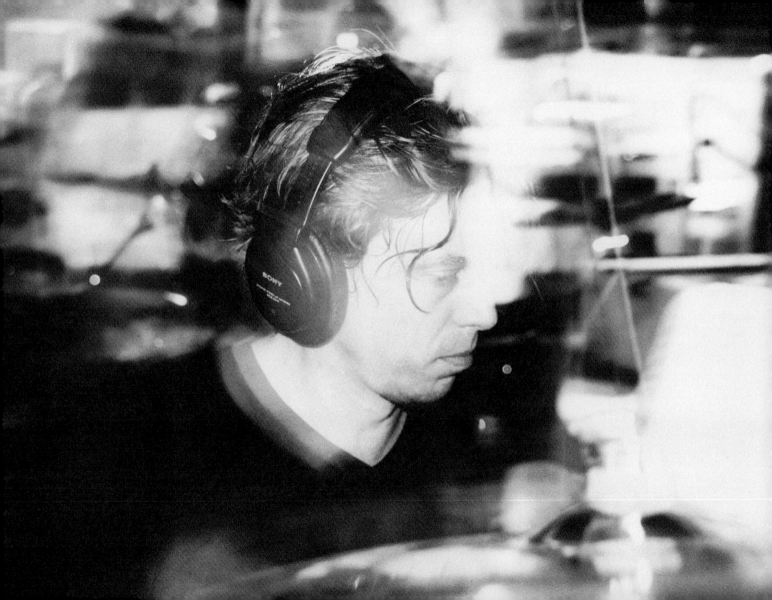

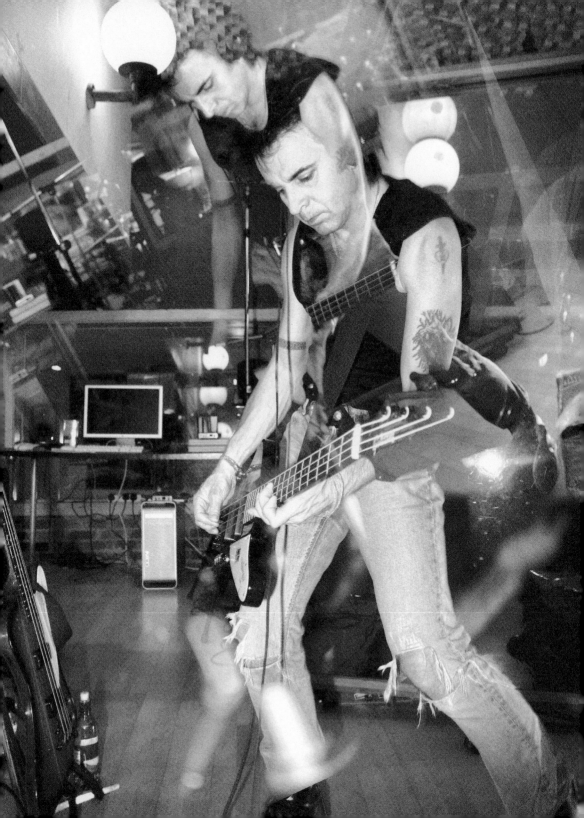

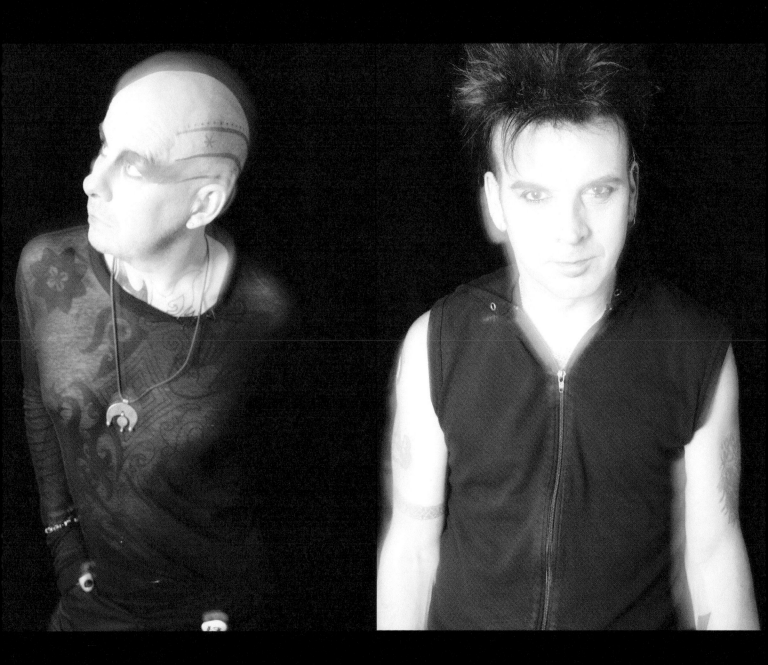

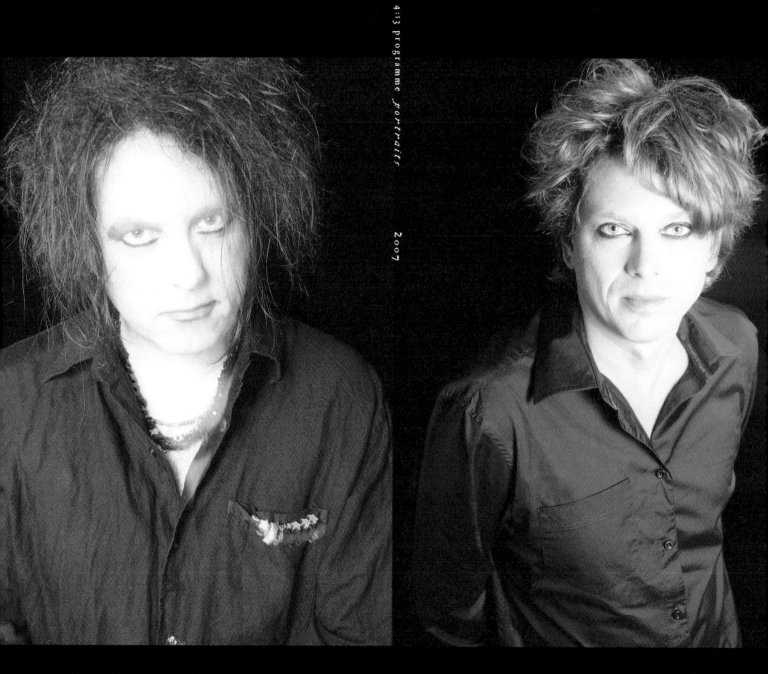

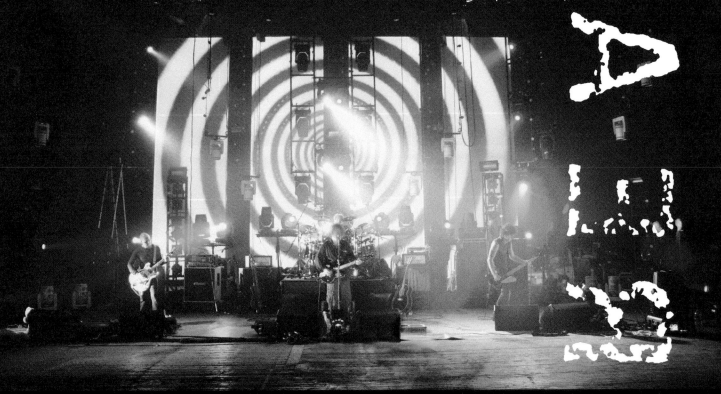

dress rehearsal *for* 4:tour 2008, london

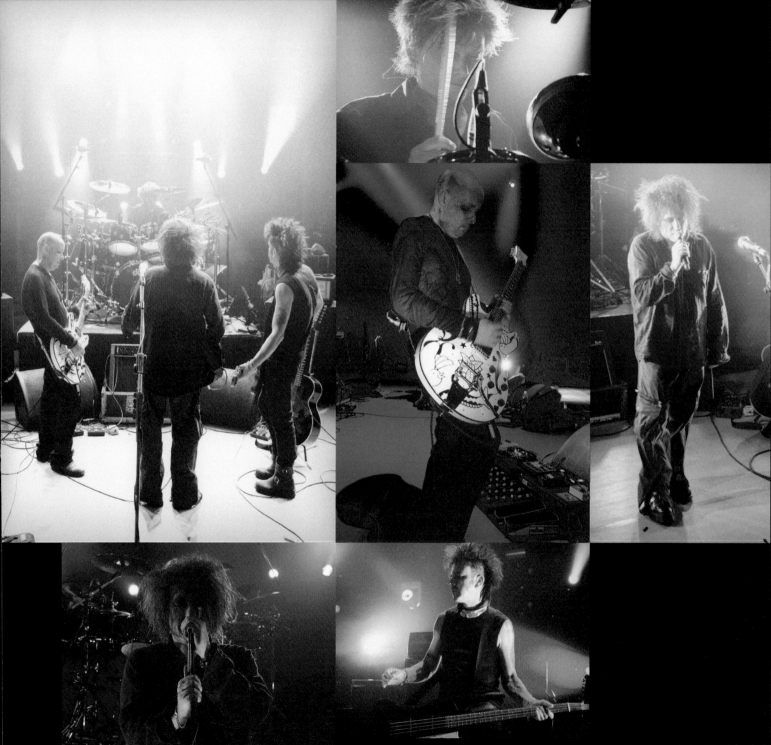

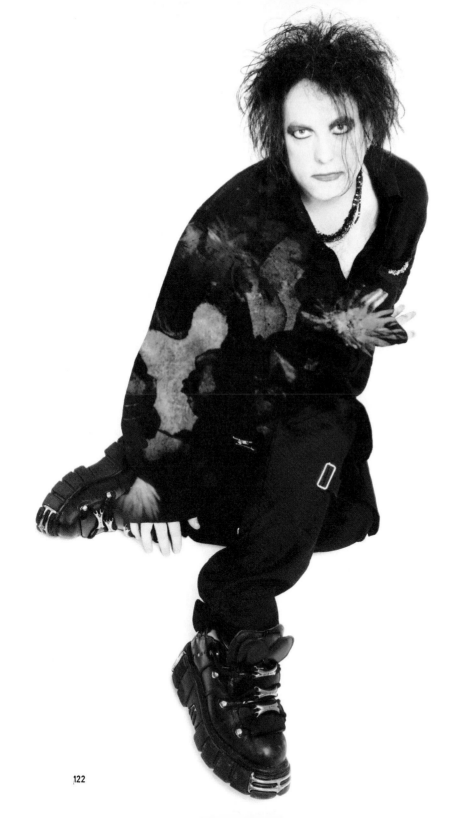

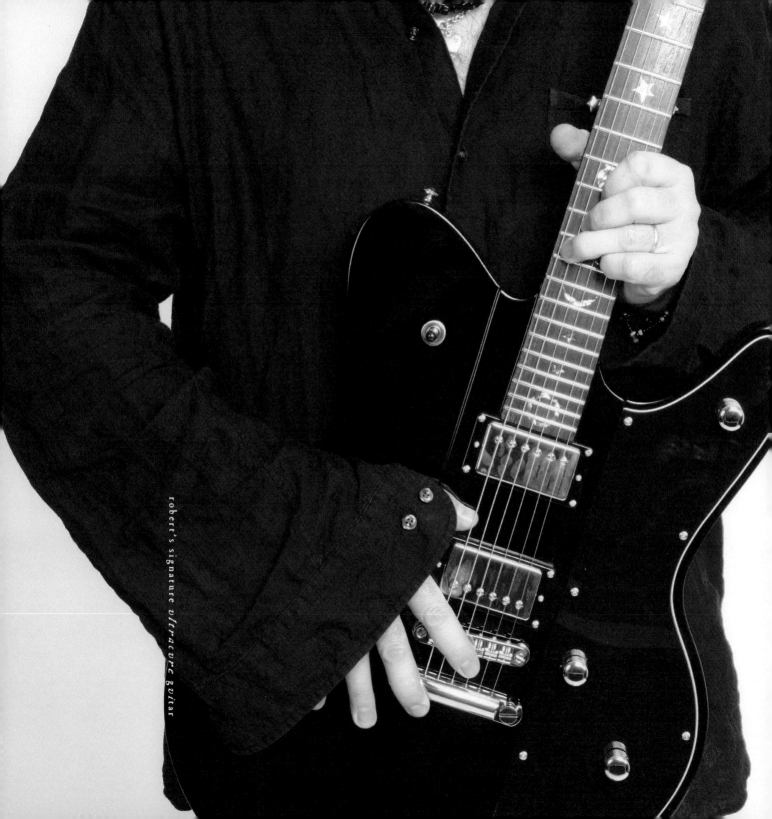

robert's signature ultracure guitar

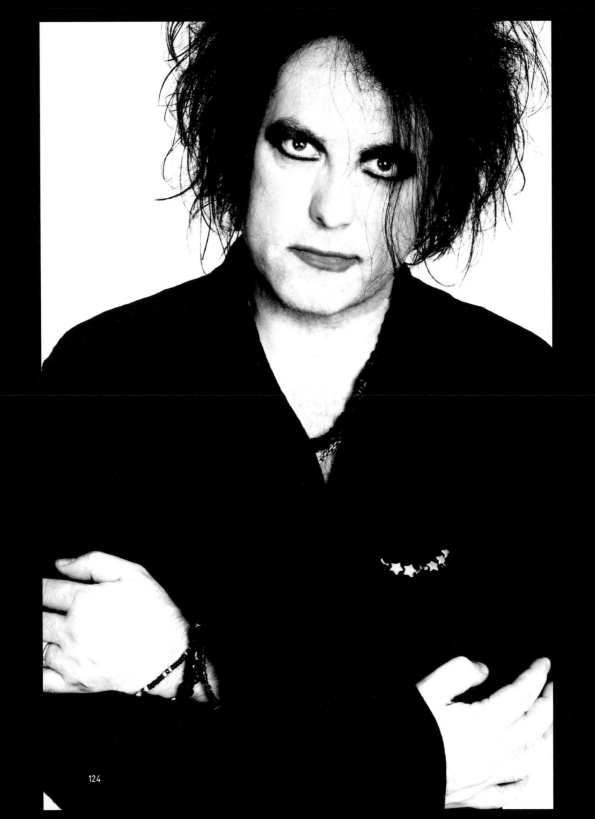

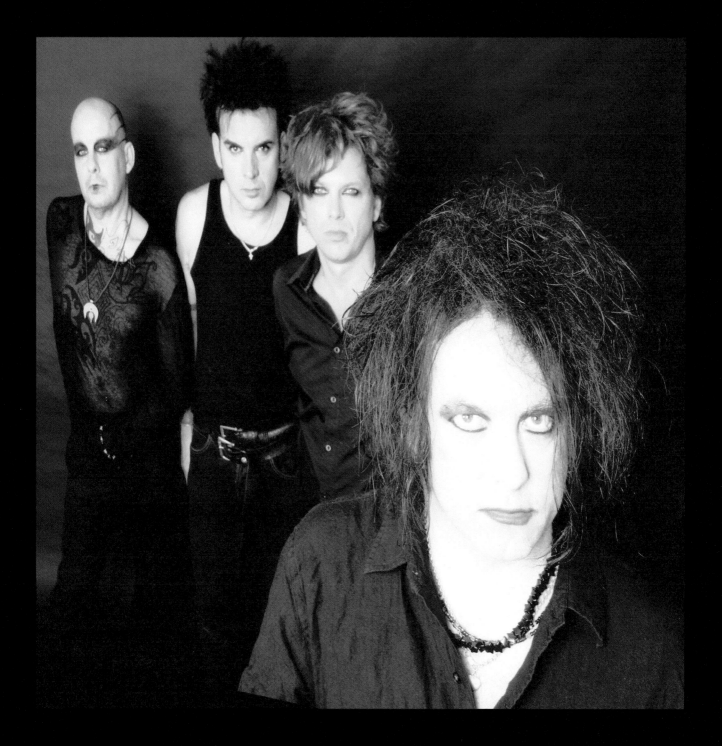

PLAY

looking forward

to bestival 2011

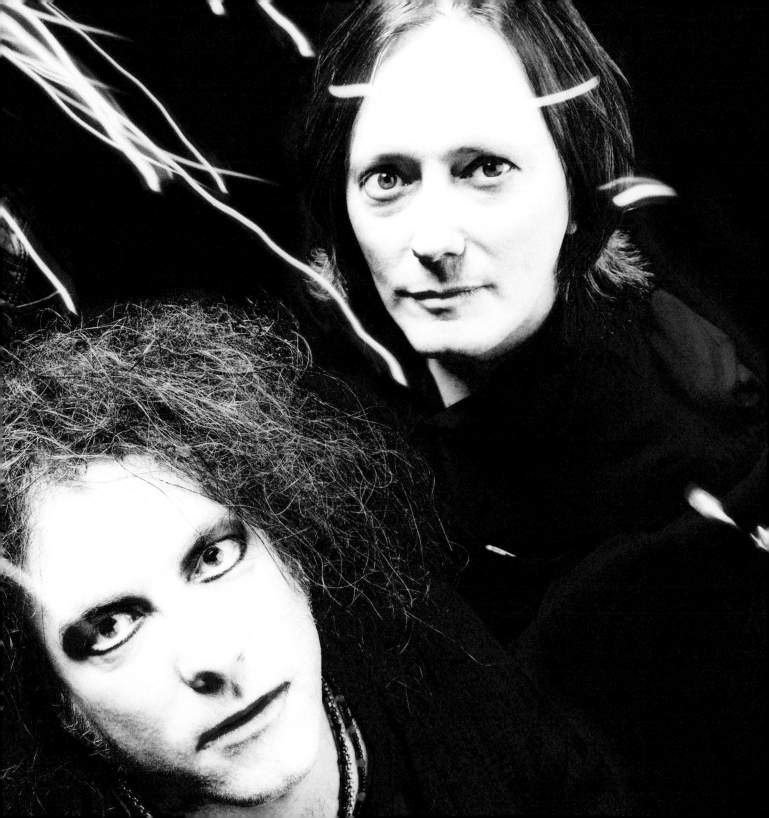

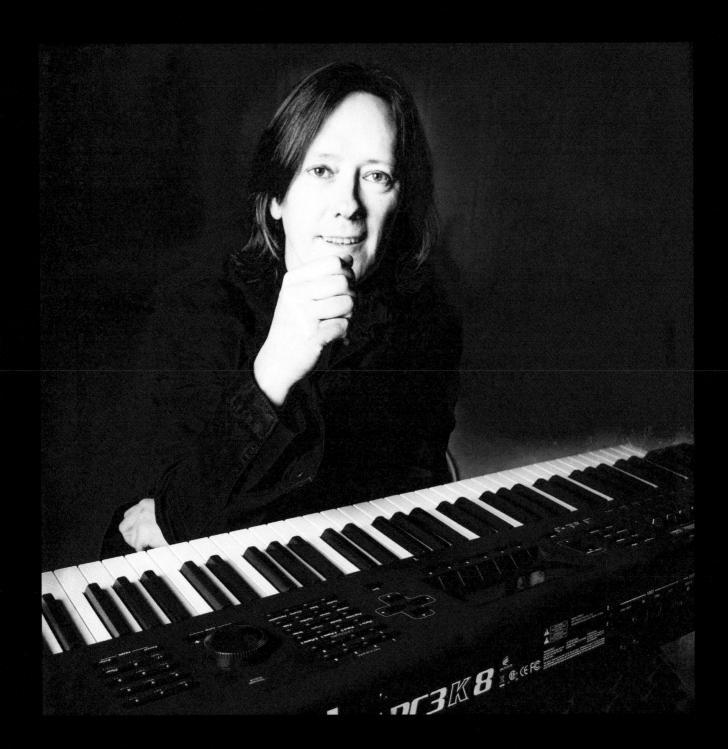

123

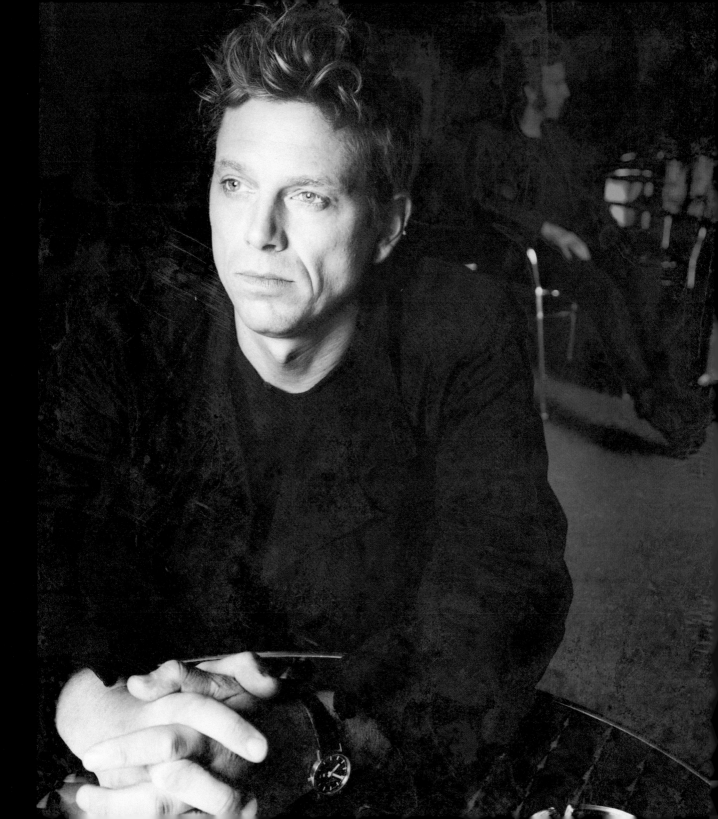

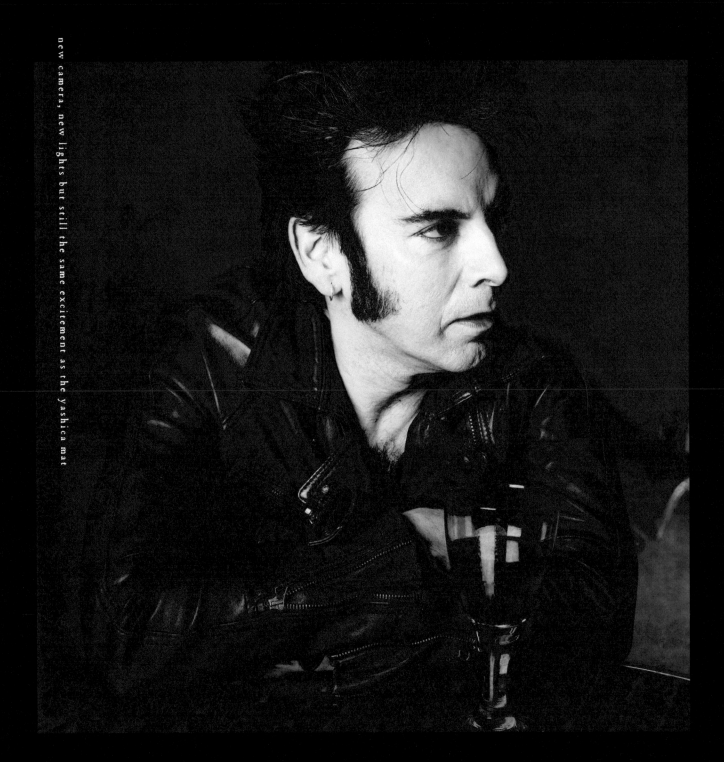

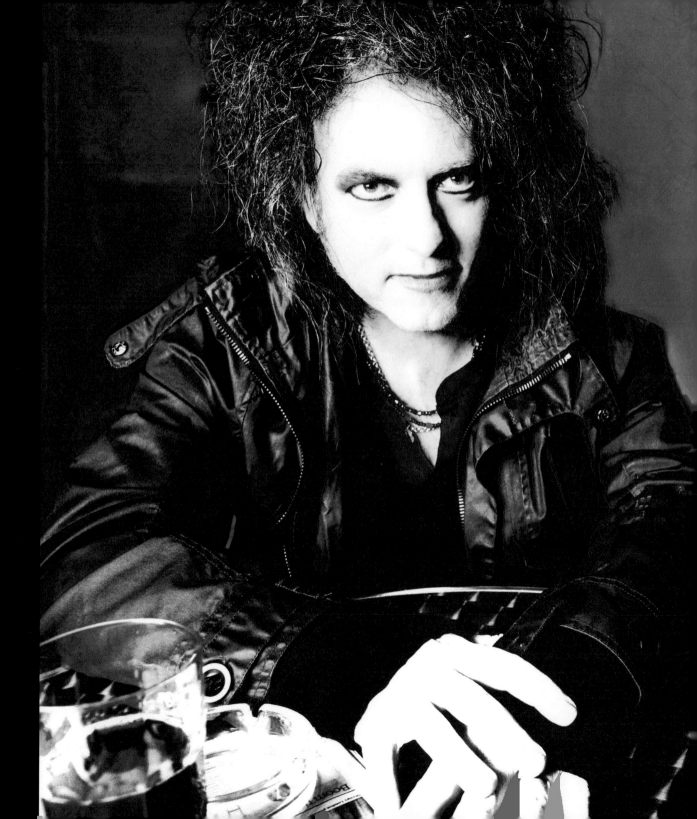

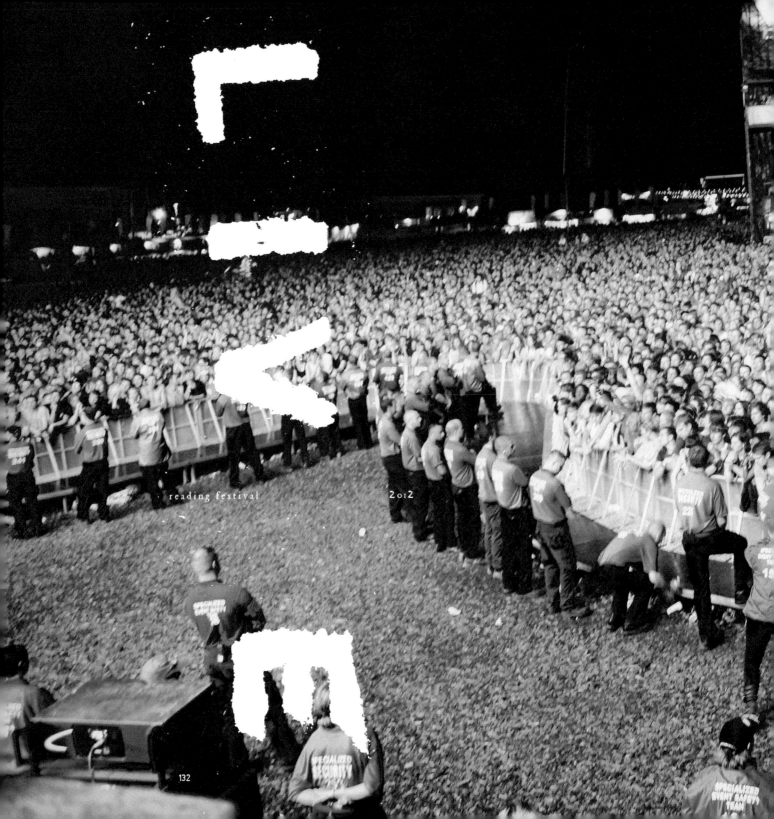

reading festival 2o12

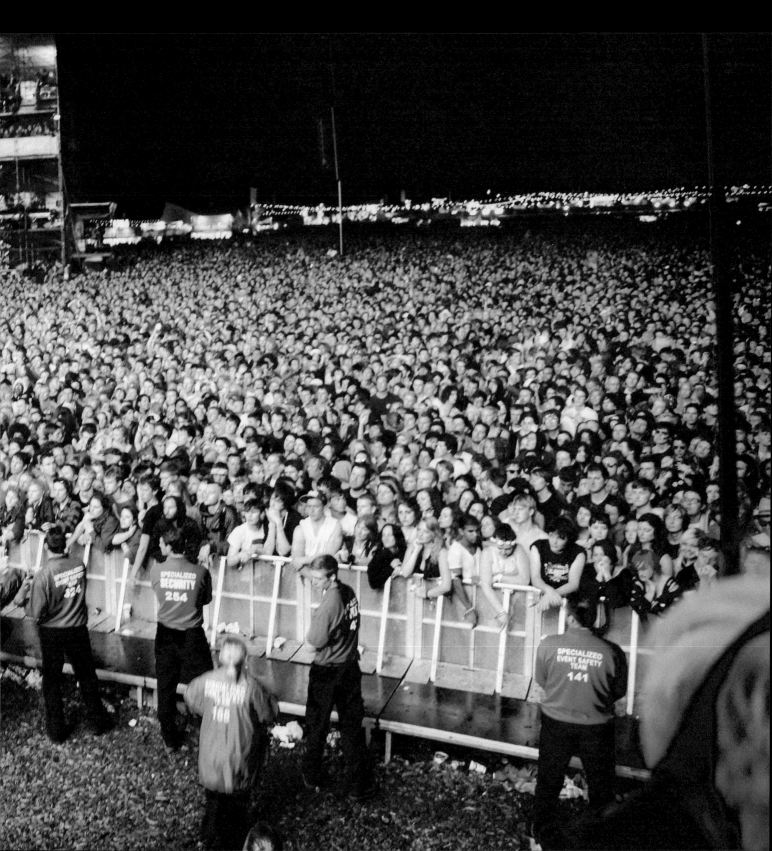

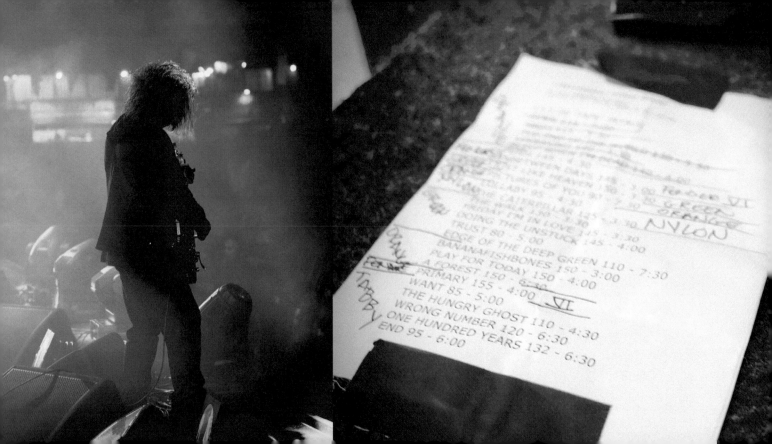

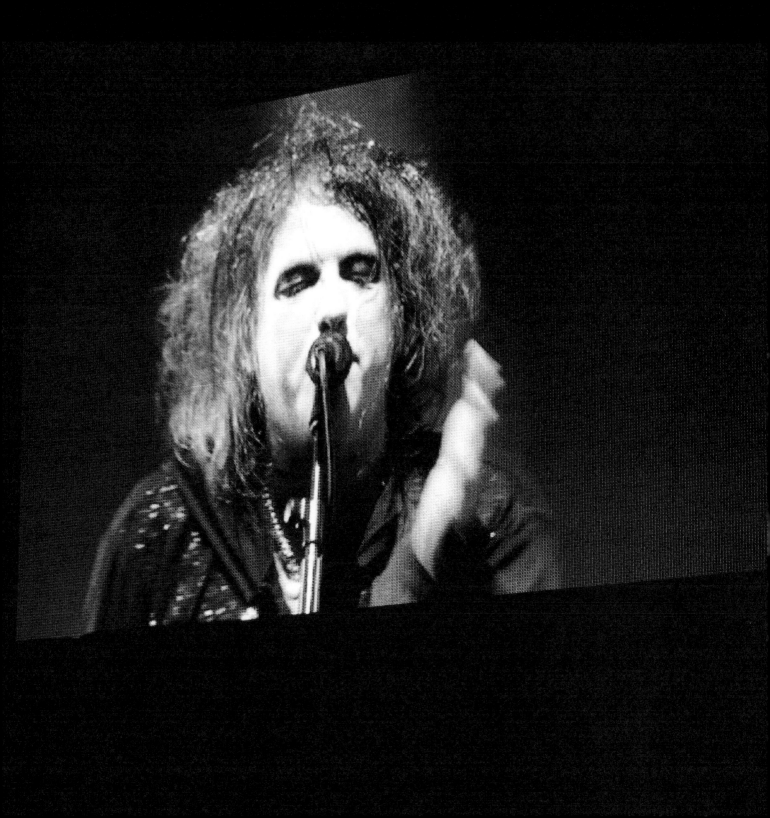

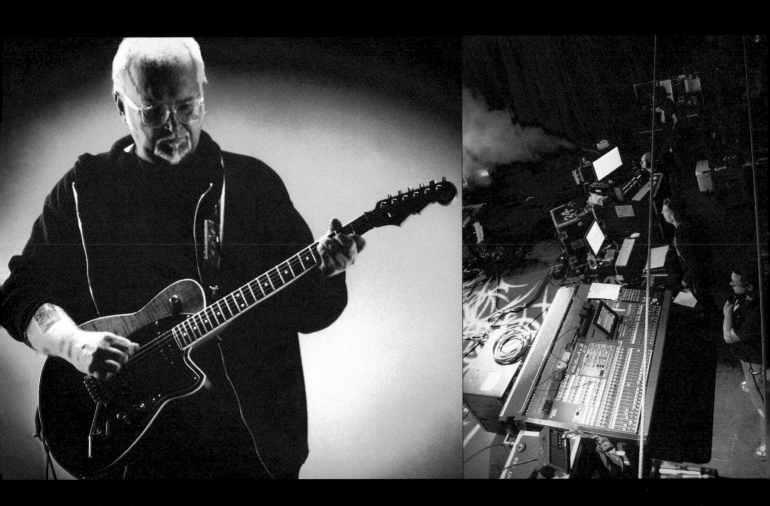

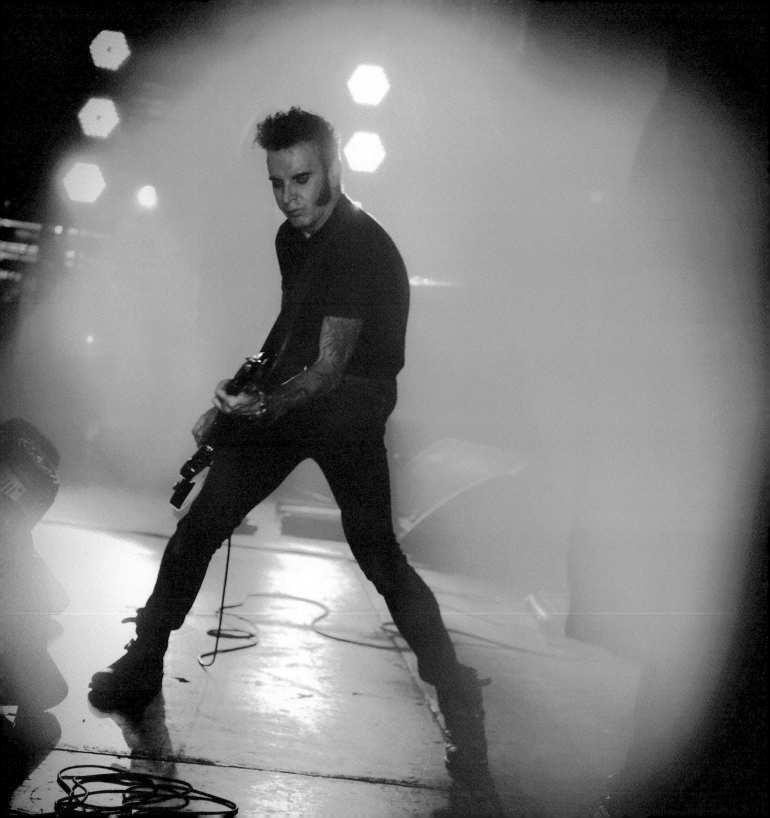

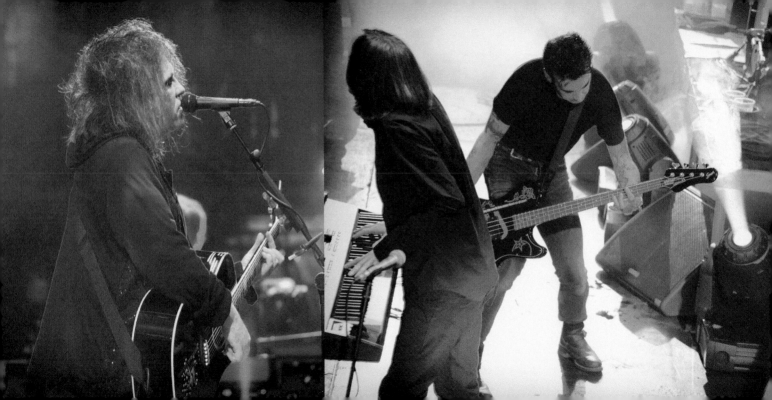

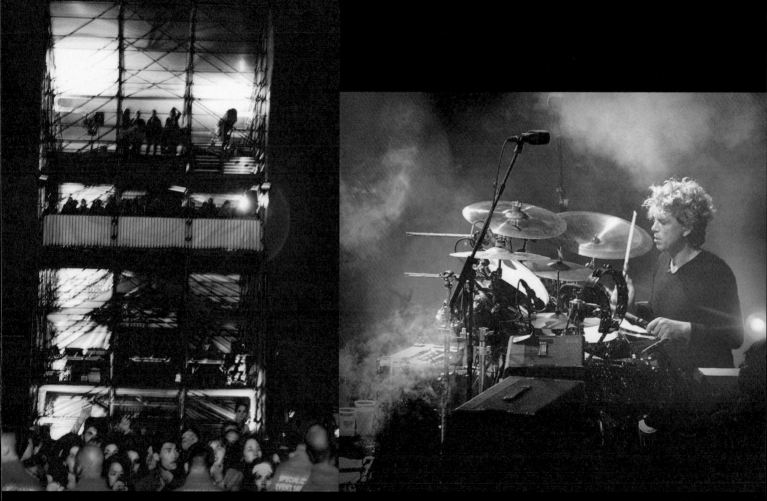

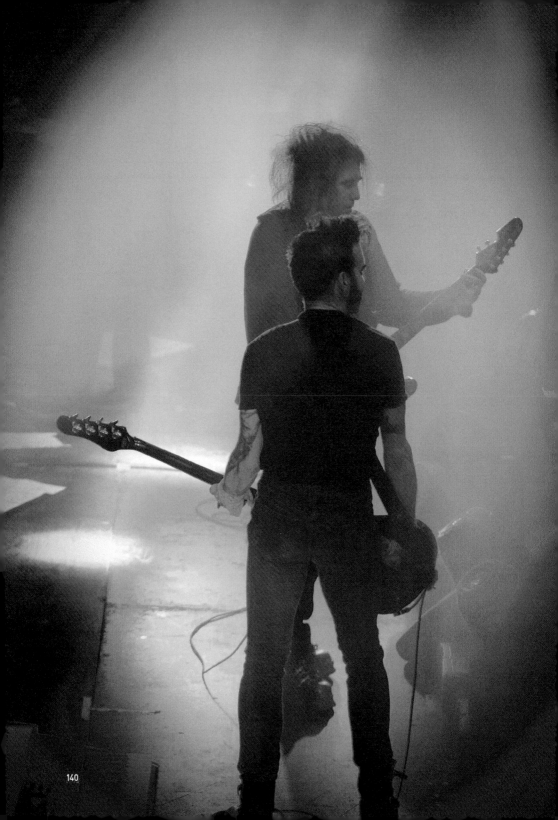

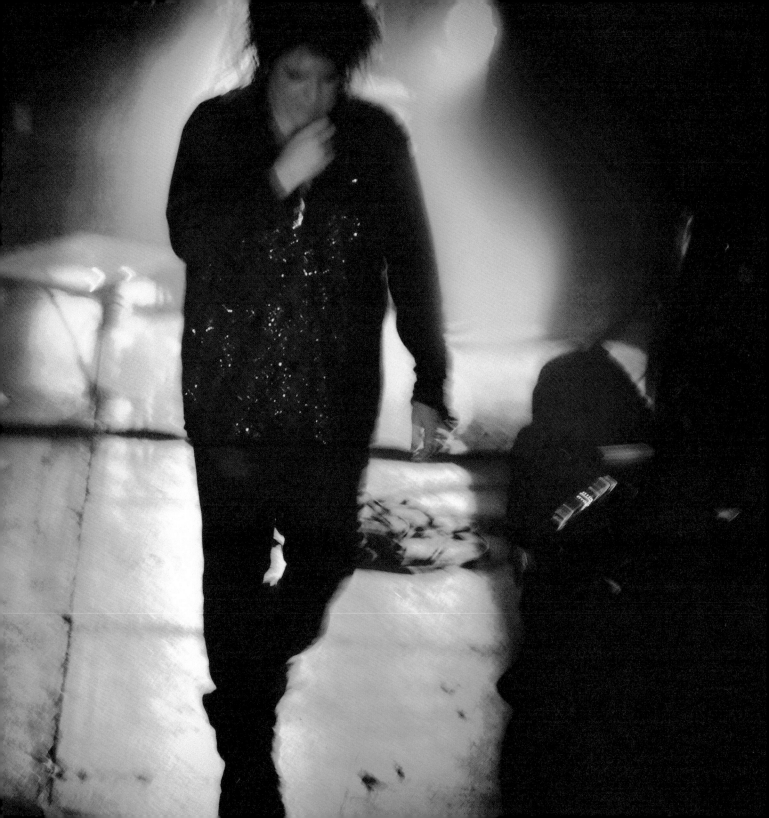

announcement shots for latam and great circle tour *shows*

2013

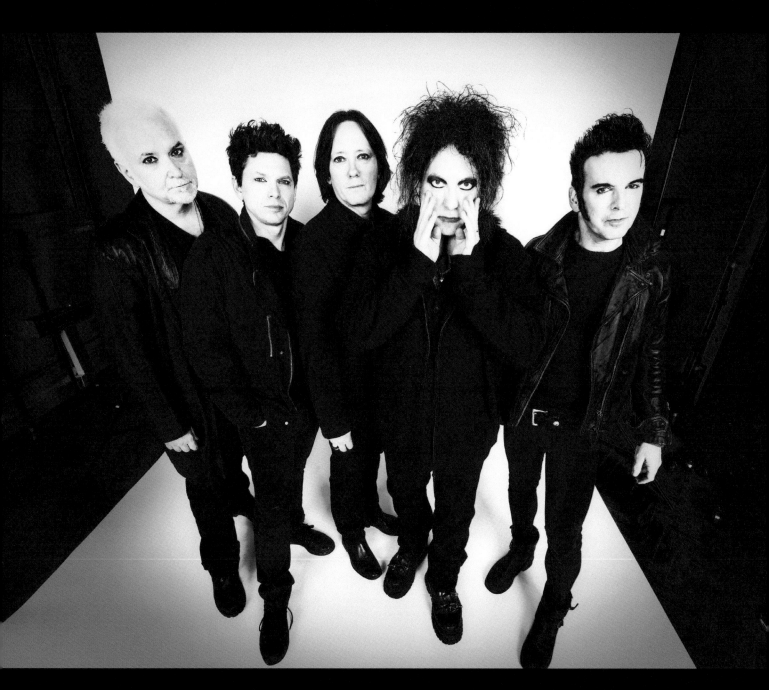

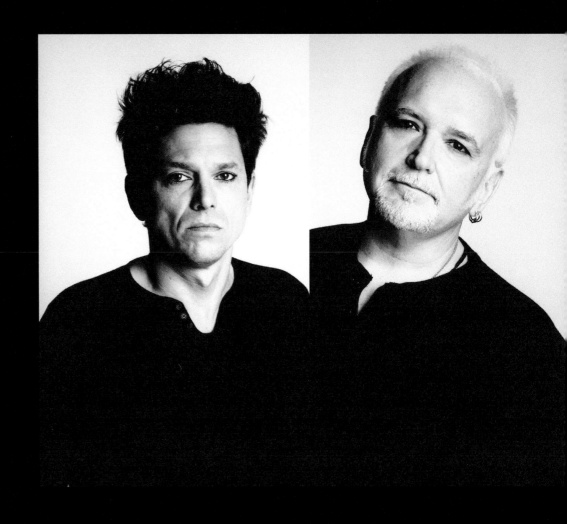

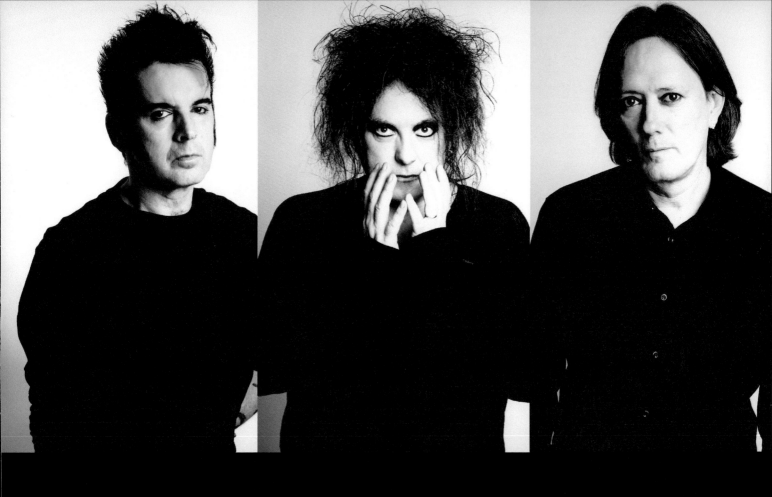

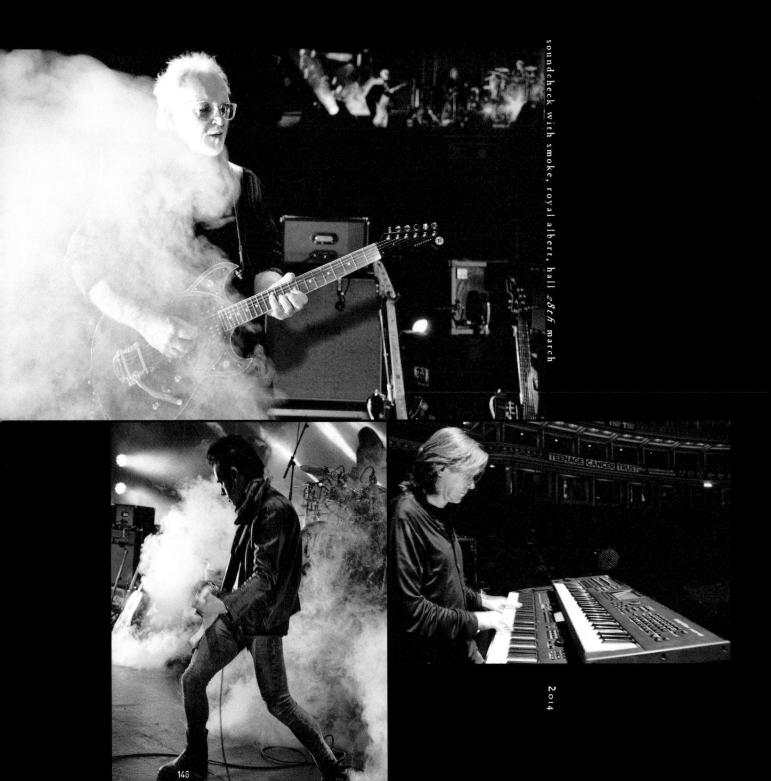

2014

148

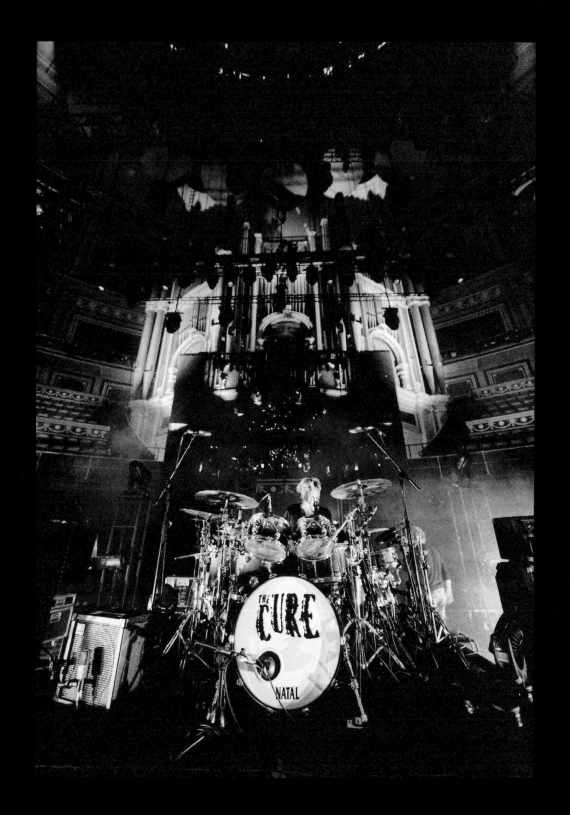

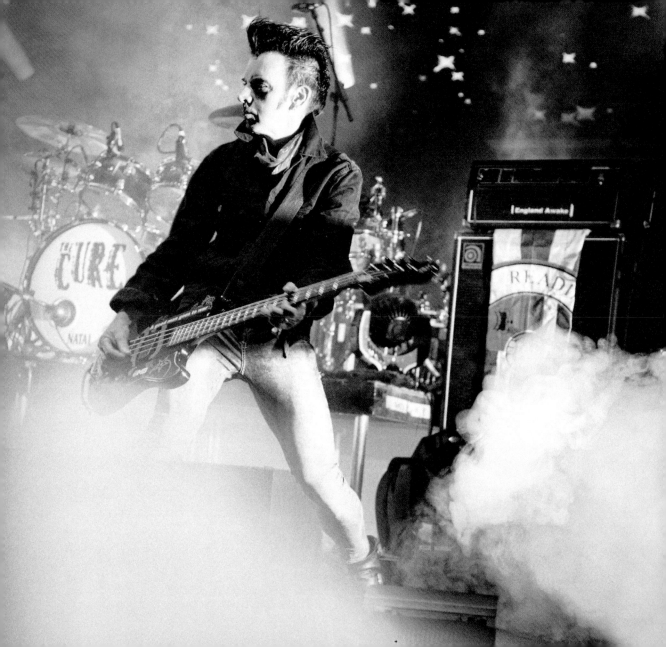

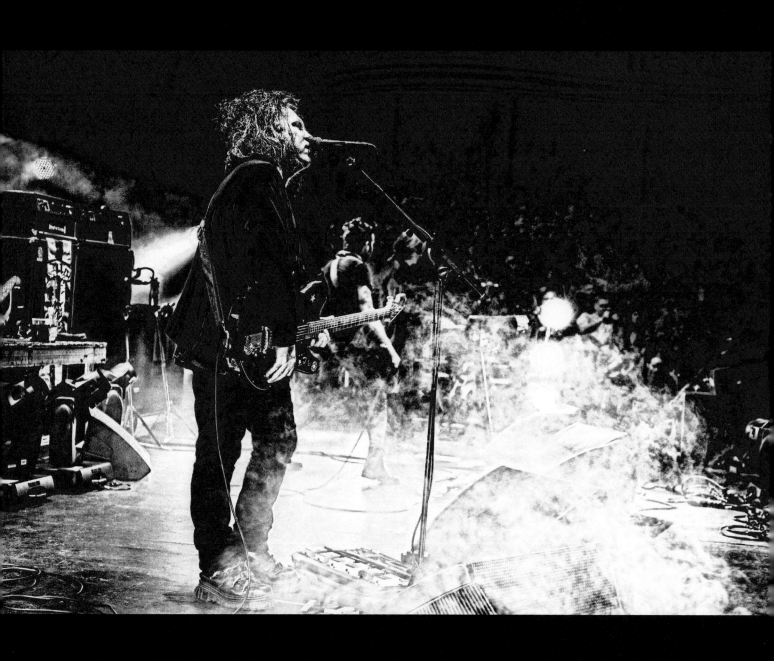

teenage cancer trust, royal albert hall *28th – 29th* march 2014

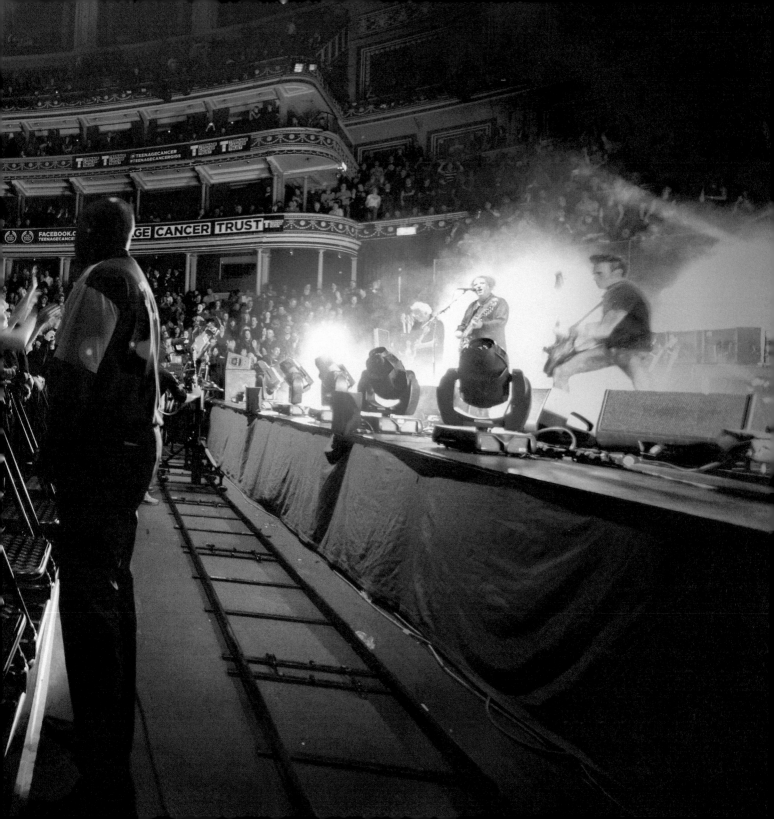

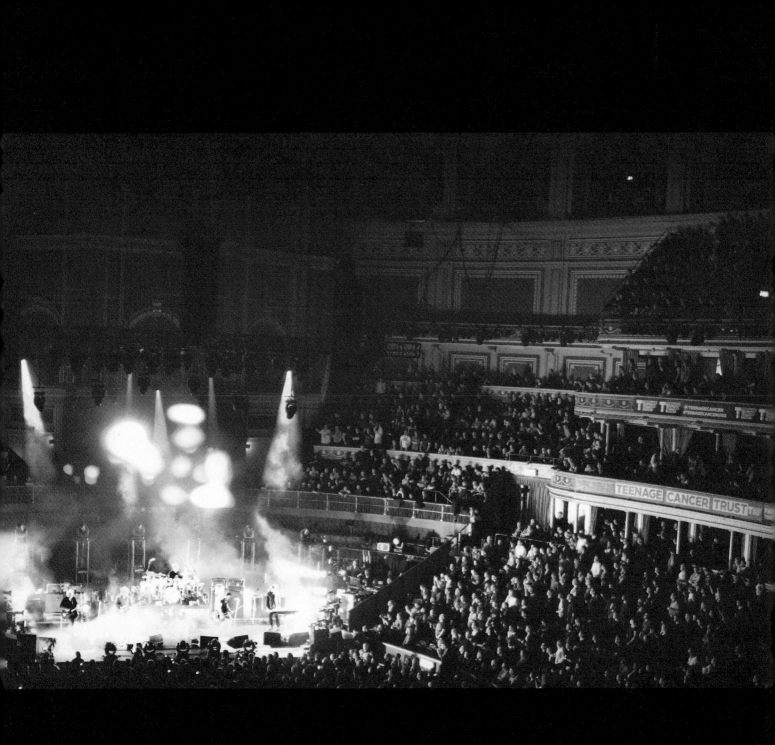

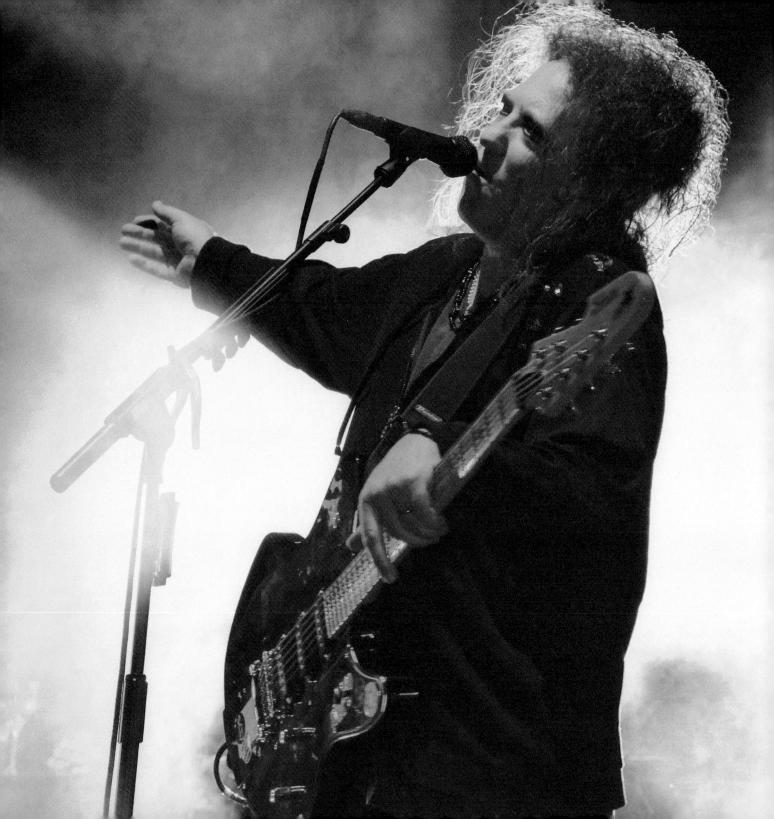

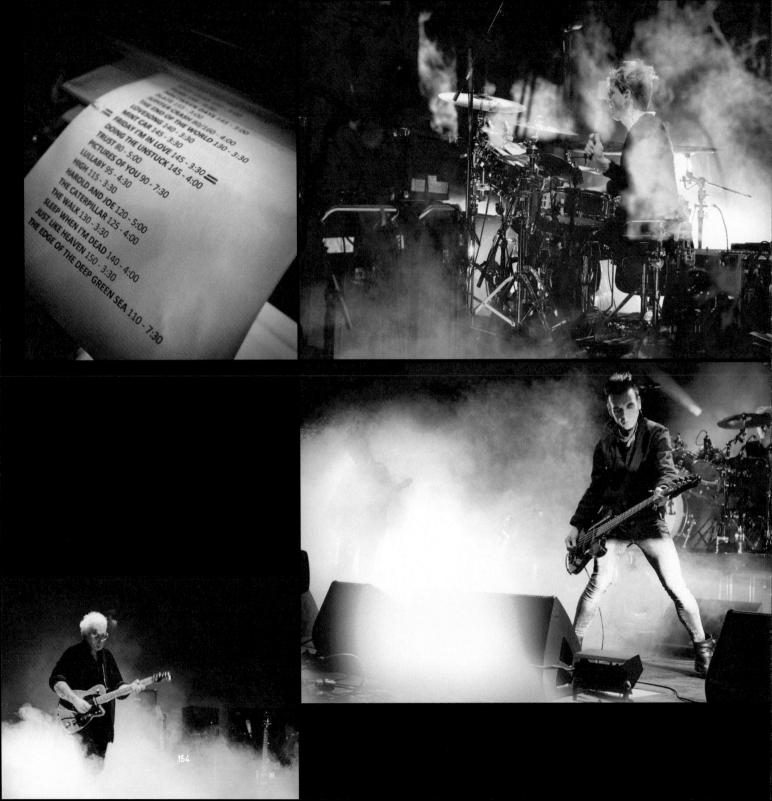

SLATE 120 DEATH 125 - 3:00
UPPER CRASH 80-160 - 4:00
THE END OF THE WORLD 130 - 4:00
LOVESONG 130 - 3:30
MINT CAR 145 - 3:30
FRIDAY I'M IN LOVE 145 - 3:30
DOING THE UNSTUCK 145 - 4:00
TRUST 80 - 5:00
PICTURES OF YOU 90 - 7:30
LULLABY 95 - 4:30
HIGH 115 - 3:30
HAROLD AND JOE 120 - 5:00
THE CATERPILLAR 125 - 4:00
THE WALK 130 - 3:30
SLEEP WHEN I'M DEAD 140 - 4:00
JUST LIKE HEAVEN 150 - 3:30
THE EDGE OF THE DEEP GREEN SEA 110 - 7:30

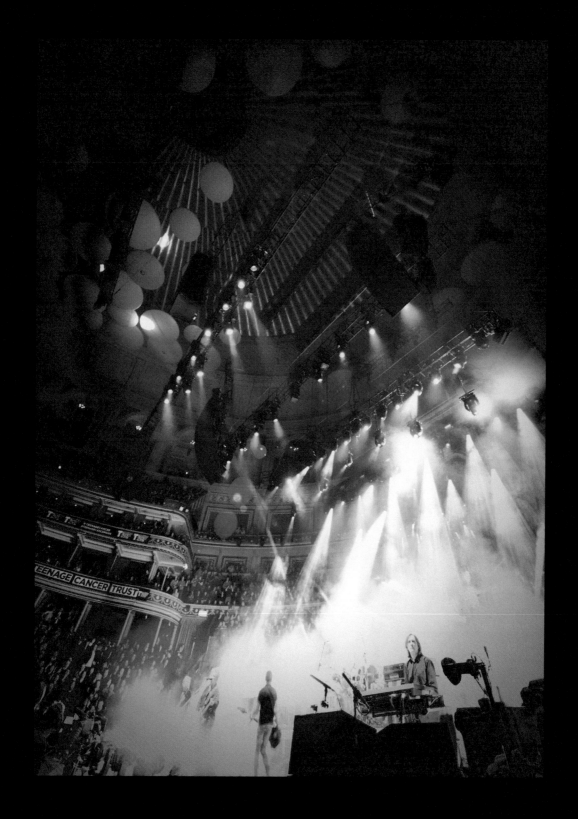

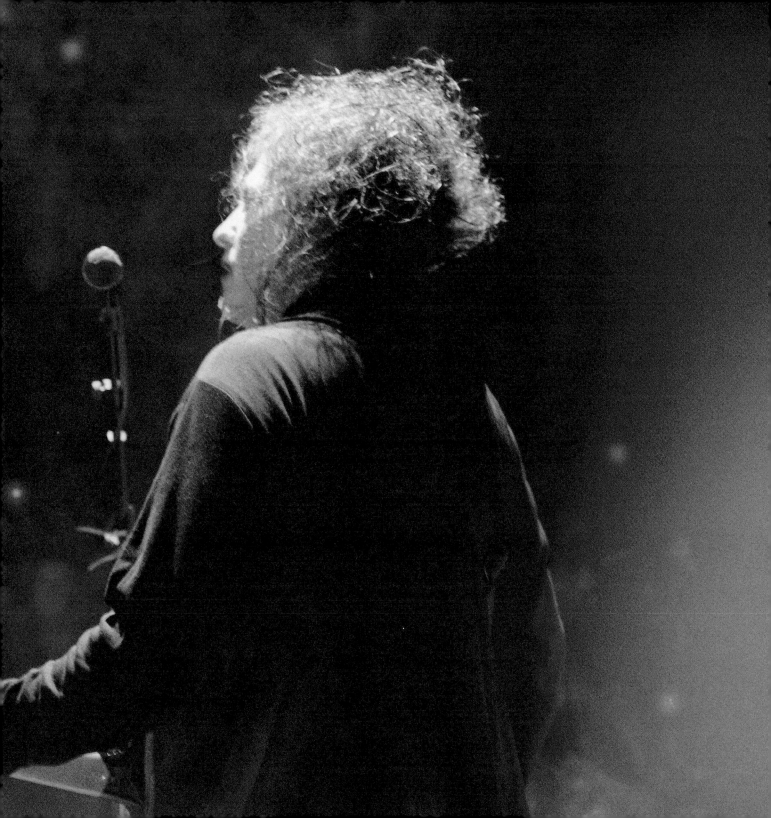

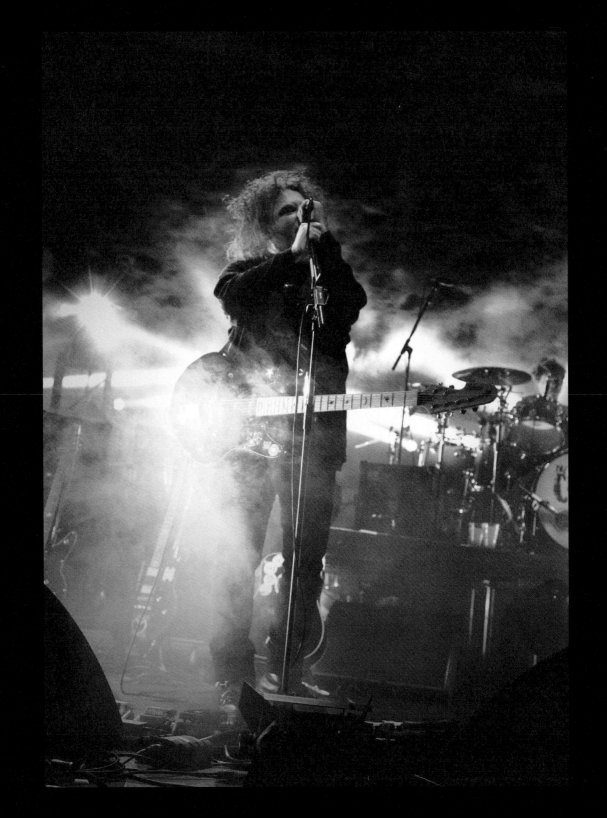

THANKS FOR ALL THE SUPPORT, HELP AND INSPIRATION

colette-my best critic, mum, dad, paul, matty, rachel, foruli, mr & mrs H, dick, mr mann, lilian & peter, mr & mrs p, the whites and mr black

heres to the next.... .

robert, porl, simon-thanks for the book! lol, boris, jason, roger-the f l a s h did go off!, janet, mary, fiction, ita, m a d g e , k e i t h , chris p a r r y, gerald, aswin *and* tim pope. the labs that showed me how, the people who told me why, *and* the cameras that helped me s e e .

Lightning Source UK Ltd.
Milton Keynes UK
UKIC01n0718210914
238903UK00003B/4